IN THE REALM OF APPEARANCES

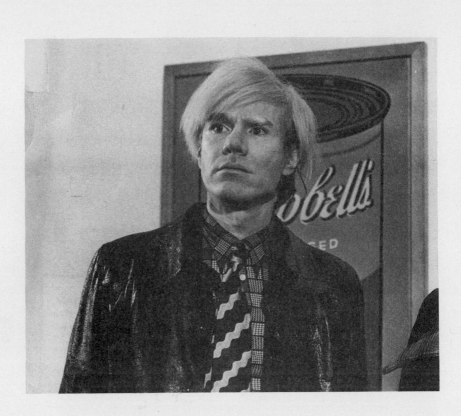

IN THE REALM OF APPEARANCES

APPEARANCES
The Art of Andy Warhol

John Yau

THE ECCO PRESS

■ ————————————————————————————

Acknowledgments

Earlier versions of a number of these chapters were published as "Andy Warhol and the Critics" and "Jeff Koons" in *ARTSPACE* (vol. 17, no. 122, March–April 1993).

Jacket image—*Big Electric Chair* (1966) by Andy Warhol—courtesy of the Photographie Musée National d'Art Moderne, Centre Georges Pompidou, Paris.

Insert photos courtesy of The Andy Warhol Foundation for the Visual Arts, Inc., New York.

Copyright © 1993 by John Yau

The Ecco Press
100 West Broad Street
Hopewell, NJ 08525

Published simultaneously in Canada by Penguin Books Canada Ltd., Ontario

Printed in the United States of America

Designed by Nick Mazzella

FIRST EDITION

Library of Congress Cataloging-in-Publication Data

Yau, John, 1950–
 In the realm of appearances: the art of Andy Warhol / John Yau.—
 1st ed.
 p. cm.
 1. Warhol, Andy, 1928– —Criticism and interpretation.
 I. Title.
 N6537.W28Y38 1993
 700'.92—dc20 92-46332 CIP
 ISBN 0-88001-298-6 $19.95

The text of this book is set in Palatino.

In memory of
Nicholas ("Nick") Wilder (1938–1989)

List of Illustrations

Frontispiece. Andy Warhol, 1971, at the Tate Gallery, London.
Photo courtesy Archive Photos/*London Daily Express*.

1. *Before and After 3.* 1962.
 Synthetic polymer paint on canvas.
 Whitney Museum of American Art, New York.
 Purchase, with funds from Charles Simon.

2. *Sixteen Jackies.* 1964.
 Silkscreen ink on synthetic polymer on canvas.
 Walker Art Center, Minneapolis.
 Art Center Acquisition Fund.

3. *Saturday Disaster.* 1964.
 Silkscreen ink on polymer paint on canvas.
 Rose Art Museum, Brandeis University,
 Waltham, Massachusetts.
 Gervitz-Mnuchin Purchase Fund, by exchange.

4. *Little Race Riot.* 1964.
 Acrylic and silkscreen on canvas.
 The Menil Collection, Houston.

5. Untitled (Rorschach Series). 1984.
 The Estate of Andy Warhol.

6. *Camouflage Self-Portrait.* 1986.
 Silkscreen ink on synthetic polymer paint on canvas.
 The Metropolitan Museum of Art, New York.
 Purchase, Mrs. Vera List Gift.

7. *S & H Green Stamps,* 1962.
 Silkscreen on canvas.
 The Andy Warhol Foundation for the Visual Arts, Inc.,
 New York.

8. *129 Die in Jet (Plane Crash),* 1962.
 Synthetic polymer paint on canvas.
 The Andy Warhol Foundation for the Visual Arts, Inc.,
 New York

I

ANDY WARHOL, Jackson Pollock, and Georgia O'Keeffe have one thing in common. They are both famous and notorious. This is what a dual-status society frequently bestows on its artists, but seldom grants its writers. For artists and writers, fame is a measure of acceptance. In describing the work of those who inhabit fame's upper slopes, critics routinely use words like "great" and "important." However, being simultaneously famous and notorious means the individual's assaults have carried him or her beyond the confines of museum and gallery walls and into the public arena. For many postwar critics, the artist's ability to carve out a niche in the public imagination is taken as proof of the global magnetism of his or her art.

Gertrude Stein and Jack Kerouac are notorious rather than famous. No one thinks of their writings as possessing universal appeal. Their works may be grudgingly recognized as innovative and even important, but they are seldom regarded as great. Many critics and writers—one imagines they should know better—are still offended by Stein's and Kerouac's assaults on writing and the public consciousness. Is it because these readers believe there is a correct way to write a sentence but accept that there is no right way to draw an apple? Or is it because critics still cling to the belief that visual language transcends national and cultural boundaries while written language does not?

Despite the fact that Hollywood has made movies based on their books, Paul Bowles and William Burroughs are not widely read authors, and their work doesn't appear on the best-seller lists. They are notorious for something that is tan-

gential to their writing. The filmmakers Bernardo Bertolucci and David Cronenberg were more interested in making the authors into characters than in turning their best-known books, *The Sheltering Sky* and *Naked Lunch*, into films. Fame means one is accepted by the public, while notoriety engenders voyeurism. The public is curious about Burroughs's and Bowles's lives. For them, the writing is interesting because it leads back to the author's life. They want to sidle up to what they perceive as a life lived in the margins, a life fraught with danger and adventure. They want to learn about someone else's season in hell. At the same time, the public has relatively harmless images of Warhol, Pollock, and O'Keeffe in mind. As Picasso predicted, Stein began to resemble his portrait of her. It is his version of Gertrude Stein that is accepted, rather than her writings.

II

THE CRITICS who would have us believe artists make history, but writers do not, pander to the idea that culture is a visual realm where both literature and literacy are no longer necessary. The person who praises Picasso's paintings, but dismisses Stein's writings, is a hypocrite. The person who believes Warhol's greatness is due to his accessibility but believes Stein was a charlatan who was deliberately obscure, is a consumer proud of being ignorant.

III

THE DIFFERENCE between Andy Warhol and, let us say, LeRoy Neiman, Norman Rockwell, and Andrew Wyeth is that the latter are famous but hardly notorious. Warhol was not only the scandalous, enigmatic darling of the rarefied art world, but someone who was mentioned innumerable times in gossip columns. His silkscreen paintings of Marilyn Monroe, Mao, "car crashes," and the "electric chair" attracted considerable public attention and changed art history, while the work of Neiman, Rockwell, and Wyeth has produced at most a ripple or two in the public mind, and not even a whisper in the various castles of the art world. However, despite the immense and seemingly irreconcilable differences in their work, Warhol deliberately connected himself with these men.

In 1976 Warhol did a portrait of Jamie Wyeth, Andrew's son and himself a realist painter; and their joint exhibition, "Portraits of Each Other," was hosted by the Coe-Kerr Gallery. The Wyeth family was the opposite of Warhol's. Andrew's father, N. C. Wyeth (1882–1945), was a well-known illustrator during the 1930s and provided images for adventure stories such as *Treasure Island*, which Warhol may have read during his adolescence. Whereas by the 1960s Wyeth's family was considered an American institution, and was celebrated in the press, Warhol's family were impoverished immigrants. His father was a coal miner and his mother a housewife; neither of them ever spoke English with ease.

In 1981 an exhibition of portraits of sports figures by Warhol and Neiman was mounted by the Los Angeles Institute

of Contemporary Art and underwritten by Playboy Enterprises. Neiman is both a jock expressionist and house illustrator for *Playboy*. His mannered action studies of gridiron giants crashing together, or young men in flannels sliding headlong into home plate, are featured next to double-page spreads of wholesome nudes, who the largely male readership (pimply boys, couch potatoes, and young execs) wish would come over and ask to borrow a bowl of sugar.

At the time of his death in 1987, Warhol owned a small painting, *Portrait of Jackie Kennedy*, 1963, by Norman Rockwell. The portrait was reproduced in the *Saturday Evening Post*, October 26, 1963, less than a month before President Kennedy was assassinated in Dallas. Shortly after November 22, 1963, Warhol chose photographs of JFK and Jackie from the mass media and used them as subjects in a series of paintings and prints.

Rockwell's paintings were reproduced on the covers of more than three hundred issues of the *Saturday Evening Post* and in the pages of countless other magazines. He was at his best when he made believable symbols out of familiar details. He could be democratically attentive to the freckles spread across a redheaded boy's face, then go on to do each strand of his cowlick. Like Santa Claus, only without hundreds of helpers, Rockwell ran a cottage industry the public could both appreciate and understand. He gave them something solid for a handful of change. An American institution by the end of the Depression, Rockwell was the master of sentimental icons to the cherished values of the middle class and one of the last sweet propagandists of family values.

Although Rockwell's works were seen in reproduction by

millions of readers, the originals were virtually unknown. Seeing a Rockwell painting was a rarity and owning one even more so. They weren't displayed in museums or exhibited in galleries. The market for his work was the magazines and the public that read them week after week, not the collector.

After Warhol's death, his estate was auctioned off by Sotheby's. It took more than a week, and the catalog accompanying what one journalist called the "garage sale of the century" consisted of six volumes in a boxed set. There were more than ten thousand items, ranging from dimestore cookie jars and Muppet memorabilia to Picassos and the French impressionists. Among the piles of things was Rockwell's *Portrait of Jackie Kennedy*, a subject the art world presumed was Warhol's. Given that Rockwell's portrait was done shortly before President Kennedy was assassinated, obtaining it was probably not all that easy. How or why Warhol came to be in possession of it has never been mentioned by anyone who knew him.

The works of Neiman and Rockwell, and to a great degree Wyeth, exist in the disembodied zone of reproductions. We see them as pictures rather than as paintings. Before Warhol became a famous artist, he was a highly successful commercial illustrator in New York. By the mid-1950s, his drawings and watercolors of shoes and other consumer items regularly appeared in the pages of *Life*, *Glamour*, and other magazines. He too made pictures and would continue to do so after he began painting in 1960. In 1962, when he began using silkscreened images in his work, he completed a reversal. The reproduction became a painting.

IV

CRITICS DEFINE Warhol in either/or terms. He is either an uncompromising genius or an accommodating charlatan, a brilliant artist or a dangerous fake, a numbing voyeurist or an accurate mirror, a producer of ground-breaking art or a purveyor of boring images, a creative presence or a destructive force. Although Warhol died in 1987, the either/or argument continues unabated because each side wants to establish and control the standards by which art and artists can be judged. This is not to say that those on the same side agree with each other, because they don't. Rather, it is to point out the existence of the extreme stances critics have taken toward Warhol and his art. This might be the case for all artists who have caught the public's attention. In the face of both widespread fame and art-world honors, such as major museum exhibitions, the critic's authority becomes incidental, like an extra appendage. Better to go along for the ride than rock the boat.

In Warhol's case, it is the public—that faceless group that ventures into museums, as much to laugh and wonder about all the fuss as to experience and be moved by modern art—that has pronounced: We may not know anything about art but we know what we like. The public likes Warhol, though perhaps not as much as they like Andrew Wyeth or Georgia O'Keeffe. They see him as a passive, indiscriminate man who had a memorable face. He was known to make oracular utterances or mumble like an inarticulate teenager. He came across as an asexual fop who wore a silver wig. He was the guy who did

paintings of well-known people and things, like Marilyn Monroe and Campbell's soup cans. It is because of the adulation Warhol received during his lifetime that critics have felt that it is their duty to take a position; he deserves the fame or he doesn't.

The problem with either/or thinking is that it is concerned with the genealogy of geniuses. Most art historians and critics find it is easier to develop and maintain the history of family trees than to explain the meaning of an artist's work. For them, lineage takes precedence over purpose. In the name of culture and art history, which they believe are synonymous, they weed out the artists they judge to be minor and superfluous in search of the great and necessary. Like stonecutters with a grand, irrefutable plan in mind, they approach art and artists as if each is being measured for a pyramid. Someone has to go at the top, while others are stuck somewhere near the bottom, and countless hordes are buried in the sand, where they belong. The more elaborate and precise the pyramid, the more refined and informed the taste. And acuity of taste, as everyone knows, is what separates the critic from the public. The best critics are those who are able to plan and preside over the construction of perfect pyramids. The well-informed public knows which ones to visit.

Those who believe in Warhol's greatness proclaim him the first postwar artist to be admired by both those who have no taste whatsoever and those who can expound upon what distinguishes a good wine from an almost great one. He was admired by both art world elitists and pop culture's masses. This alone

singles Warhol out for special attention. However, those who dismiss Warhol look upon his fame, and its whiff of notoriety, as proof that the standards of quality have been lowered and that the barbarians have breached the gates.

V

CRITICS CONSIDER themselves the privileged citizens of one of two fictional worlds: Eden or Mammon. The former group believes in universal meaning, and the latter group proposes the death of art, as well as the end of meaning. The critic who believes art is made in Eden is usually a Formalist, while the critic who sees art as evidence of Mammon bases much of his or her thinking on the precepts of Hegel and Marx. Of course, there are exceptions. Hilton Kramer wishes the art world were Eden, but knows he cannot escape Mammon, and that galleries and museums have become purveyors of decadent values and crass greed. He and Benjamin Buchloh, who believes painting is an obsolete, inadequate practice, are distant, feuding cousins.

During the 1980s, when Formalism was seemingly undermined by the views of Walter Benjamin, Roland Barthes, Michel Foucault, and others, many older critics decried the change in the art world while younger critics saw a chance to establish themselves by celebrating what the collectors were buying by the truckload. Barbara Rose, a critic who first made her name in the 1960s, publicly longed for a world that she believed she helped map out, and kept pronouncing how everyone had lost their way. She was a cop trying to redirect traffic. Jerry Saltz, a younger critic, wandered around in galleries, museums, and studios, wide-eyed as one of the innocent children Walter Kean used to paint on black velvet. Saltz drank everything in, as if he were a tourist on a wine-tasting trip. Like the gossip columnist Cindy Adams, Robert Pincus-Witten, a critic who had deftly survived the change from minimalism and pop art to the neo-

expressionism and neo-geo, told the reader who was on their way in, and who was on their way out, in the fashionable downtown art scene. Defenders of Eden, these critics believed in a world in which the artist is a force of nature, an innocent child capable of showing something the viewer is afraid to see.

During the 1970s, when Rosalind Krauss saw the art world changing, she moved from Eden to Mammon, and began articulating a view that synthesized the principles of Formalism and Marxism. In the mid-1960s, she dismissed Jasper Johns because he wasn't a pure painter. At best, Johns was a follower of Duchamp, whom Krauss considered a failed Cubist. By the 1980s, Krauss, having reinvented her persona, began announcing that Duchamp was central, and that artists such as Sherrie Levine and Allan McCollum were his legitimate heirs. Thus Krauss, who once believed in pure painting and art about art, began asserting that art could still be pure as long as it celebrated its own death. Like Yve-Alain Bois, Benjamin Buchloh, and Hal Foster, Krauss combines aspects of Eden and Mammon. She believes artists, if they want to be part of their time, have to have a historical goal in mind, which is proving the death of art.

For the critics who believe in Eden, art exists before experience and meaning, while the sages of Mammon have concluded that all experiences and meanings are known, and that nothing new, original, or even insightful and authentic, can be found in either art or life. The world of time and chaos is either something not yet grasped by the innocent, or is already something packaged and consumed by the world-weary citizens of Mammon. The defenders of Eden hoist the banner of universal

appeal, while the vigilantes of Mammon believe that money rather than meaning determines visual culture. In both cases, critics are more interested in power than in art: they want to maintain what power they have achieved, as well as exert more power over artists and their work. They want to be prophets and have artists listen to them. Rather than look at art and attempt to discern its meaning, they discuss their models of the truth. One is reminded of hooded figures vehemently arguing over how many angels can boogaloo on the head of a pin.

VI

FOR MANY art historians and cultural theorists, Warhol occupies the apex of a pyramid that was started around 1960–1962. Off in the distance one can see the pyramid honoring Jackson Pollock. A little behind that, and looming over all the pyramids of this century, the ones already built and the ones the workers are still hurrying to finish, is the pyramid to Pablo Picasso, a complex edifice whose many rooms and chambers have yet to be fully explored. Finally, adjacent to Picasso's immense monument to culture is the Marcel Duchamp pyramid, which contains, among its many fabled treasures, an illuminated chamber whose interior can be seen only by peering through a single peephole.

Those who see culture as a landscape dotted with pyramids of all sizes are determined to construct their models according to a set of ideals. Life and art, it seems, must fit a theory. The idea that life and art can fit a theory is a noble one and goes back as far as Plato and Aristotle, if not farther. Plato gave us pure form, while Aristotle asserted that each and every thing could be categorized. The former posited the existence of ideals beyond the ordinary things of this world, while the latter argued that every actuality we encounter can be recognized from previous experience. Thus, by substituting utopia (or the "elsewhere") and categories (the realm of appearances) for experience and change, Plato and Aristotle helped remove us from the constantly metamorphosing physical world, as well as from the continuum of time.

Culture is born when individuals imagine ways of escaping

nature, which is change and its consequences. Continuing in the tradition of Plato and Aristotle as it has been refined and revitalized throughout history, contemporary critics have idealized an imaginary horizon, as well as the importance of stability and continuity, to the point where many actually believe there are events that prove their theory about the progress of culture and art. The telling of history is simultaneously the characterization and categorization of these events.

Andy Warhol is such an event. The critics who reside in Eden believe Warhol is a populist who broke down the barrier between high art and mass culture and made art into something that could be instantly understood by everyone. He demystified art and turned out products that were instantly legible. His genius was that he did this without being nostalgic for earlier models of art, for realism or impressionism, for example. In their eyes, Warhol enlarged the subject matter of art, made it a force that could capture the most important changes in society, as well as document its most mundane things.

The critics who inhabit Mammon believe that painting is no longer a viable artistic act, and that the history of painting has come to an end. For these theorists and critics, Warhol's art is proof that painting and art history have died. For them, Warhol brought painting to its logical, historical consequences, made it an obsolete practice. Thus, one could say the century started with the building of the Picasso pyramid and ended with the smaller, sleeker, and more up-to-date Warhol pyramid. This view implies that the twentieth century is when painting was reborn and died.

VII

WHETHER FROM Eden or Mammon, Warhol's supporters agree
that he contributed to the further erosion of what they assert are
old and obsolete standards (the heroic artist alone in the studio,
transcendent meaning, self-expression, and the valorization of
the art object). They point out that he, more than anyone else,
opened the door between high art and popular culture and thus
called into question the very purpose and meaning of art. In
their eyes, Warhol's use of well-known images simultaneously
subverts something deep in American culture and connects
high-minded sophisticates with the mass of know-nothings. It is
an art admirable for being both critical and democratic. It is an
art whose meaning is transparent, like a window overlooking a
world we all inhabit. In Warhol's art, we are supposed to see
ourselves and the common world—one that is part Eden and
part Mammon—we share.

VIII

TOPPED BY a silver wig, Warhol became as recognizable as his images of Campbell's soup cans. The public may know what Wyeth's *Christina's World* looks like without ever having seen it, but they have no idea of the face of the person who painted it. Warhol's degree of recognition, one might also call it marketability, puts him on an equal footing with van Gogh and Rembrandt, two artists whose faces have been appropriated by the mythmaking machinery of consumer culture. As with van Gogh and Rembrandt and their work, Warhol and his art became a series of images that were packaged and sold throughout the world, from high-priced galleries and auction rooms to inexpensive card shops and flea markets.

During his lifetime, Warhol existed in that interior spectator space: the public imagination. It is what links him with van Gogh and Michael Jackson. Besides fame, what do these three men have in common? Van Gogh cut off his ear and held his hand in a fire, Warhol had a nose job and wore silver wigs, and Jackson has had plastic surgery and wears one white glove. Each man deformed himself in the name of an ideal. The public is sympathetic to them because they too subscribe to ideals they know they will never attain.

IX

MOST DETRACTORS argue that Warhol and his work represent further proof of the decline of Western culture. They have a Golden Age or ideal in mind. They claim that Warhol couldn't draw, that others chose his subjects, that he didn't think for himself, that he was inarticulate, and that he was at best a producer of boring images as well as states of boredom. For them, Warhol's fame is a clear indication of the growing emptiness of both modern art and contemporary life. If his work is, as he once claimed, a mirror, then what it mirrors is the cultural wasteland we can't escape.

X

WAS HE as impersonal as a machine in his selection of images?
Was his "blankness" the only response one could make in the
face of a reality defined and ruled by the mass media? Does his
work embody the death of the author? Did he do as he claimed?
Did he at some point begin doing what others claimed he had
accomplished? And if he got stuck inside his image and began
doing what was expected of him, does it mean that he could not
escape the clutches of his flatterers, their images of him? Or does
it mean that Warhol was afraid to become someone both soci-
ety and critics wouldn't recognize?

XI

WARHOL FIRST exhibited his thirty-two paintings of Campbell's soup cans (except for their flavors, they were the same) at the Ferus Gallery, Los Angeles, in the summer of 1962. Now, more than thirty years later, the question is not whether the old ideals of originality and artistic heroism are better than the new ones. It is not even whether the new ideals of mechanical reproduction (repetition) and the death of the author are a more accurate summation of the times or not. Instead of choosing this or that ideal, the standards associated with modernism or postmodernism, one must attempt to uncover the assumptions inherent in the ideals Warhol and his art are said to either so fully and radically embody or so completely and cynically negate. Rather than falling into the either/or argument and continuing a discourse that has more to do with theory than with Warhol's art, and what it means, we ought first to remember that ideals are a combination of half-truths and notions of conformity that a society or group declares is necessary to cling to at a given moment. What one should try to discover is the meaning of Warhol's art, which is a very different act from saying what one thinks it means.

XII

"Genius" and "charlatan" are attributes. They describe the aura of an individual rather than his or her substance. In the case of Warhol, it is necessary to get past the aura, something he worked tirelessly his whole life to create, and reach the latent meaning of his art.

XIII

WARHOL HAS been described as the prince, queen, or pope of pop (though for many reasons not the pop of pop), silver angel of death, holy fool, provocative instigator, naive innocent, decadent romantic, stargazer, voyeur, and Drella (a combination of Dracula and Cinderella). His art has been termed cool, passive, vulgar, perverse, callous, hip, detached, monstrous, faithful, witty, and ambitious; and it has been praised as both a weather vane of the times and a harbinger of things to come. Critics have placed Warhol and his work on a pinnacle that seems unapproachable. The best we can do is gaze up at them, much as one does when kneeling in a church and looking at the altar.

In writing about his first retrospective at the Whitney Museum of American Art, Barbara Rose asked: "Can a boy from a poor Czech mining family in Pennsylvania find happiness in life as the wealthy and fabulous queen of the New York art and fashion world?" (*Autocritique: Essays on Art and Anti-Art 1963–1987*, Weidenfeld & Nicolson, 1988). Warhol does not live up to Rose's ideals of the male artist as a knight or prince in shining armor, and her sarcastic use of "queen" is meant as a personal insult. She is disgruntled by all the attention Warhol has garnered, but feels it would not be in her best interests to go against the tide of praise being heaped upon him. The best she can do is comment on him out of both sides of her mouth.

Summing up Warhol's exhibition of society portraits at the Whitney Museum, New York, in 1979, Peter Schjeldahl asked: "Has there ever been an artist who so coolly and faithfully, with awful intimacy and candor, registered important changes in

society?" (*Art in America* 68:5, May 1980). Schjeldahl's question is meant to be unanswerable and thus an indication of Warhol's unimpeachable status. If he knows the answer to his sixty-four-thousand dollar question, he is certainly not letting the reader in on it.

A decade later, in his contribution to "A Collective Portrait of Andy Warhol" (*Andy Warhol: A Retrospective*, Museum of Modern Art, 1989), Julian Schnabel gushed: "There are rocks, the sea, and the sky; the days, the hours, the minutes; pain; the temperature of a particular day—all permutations of reality—and there is Andy Warhol." Schnabel concluded his litany with "What Andy chose to select is as impossible to decipher as any of the great unfathomable mysteries, like the sky, the sand, or the wind." Schnabel's corny ode to nature typifies much of what has been said about Warhol, which is ironic. The artist who helped demystify art has, it seems, become an impenetrable mystery.

After reading overheated testimonies such as these, and there are reams of them, one wonders if the authors are bully flatterers trying to outdo each other at the court of Louis XIV or two critics and an artist offering us insights into the prince of pop. Their effusions are meant not only to evoke the power of Warhol's aura, but also to remind us (lest we forget) that he is a star, and that stars are forces of nature, something beyond our mortal grasp and puny human intelligence. There is another reason why Schjeldahl, Schnabel, and even Rose are so smarmy. They want to let the reader know that they have been privileged enough to have gotten next to Warhol and to have witnessed his aura directly, whereas the public does not possess

the right credentials. The barricade between art and life may have been broken down, but for them the artist is still royalty. Thus, what we have in the case of Warhol and his art is a convergence of hollow praise, the trumpeting of the indisputable correctness of certain aesthetic theories, and the smug celebration of the social gaps separating those few in the know from the mass of wannabes. The result: Warhol's work is a blur, something we think we know but have failed to examine.

XIV

ARTHUR DANTO sees Warhol as embodying the end of painterly options available to the Western tradition. He is the last artist, a towering, antiheroic figure who initiated the end of art history. About Warhol's exhibition at the Stable Gallery, New York, 1964, his presentation of boxes one might see in a supermarket, Danto wrote in his book, *Beyond the Brillo Box: The Visual Arts in Post-Historical Perspective* (Farrar, Straus, and Giroux, New York, 1992), "I was at the time less interested in what made them art than in the somewhat different question of how they could be seen as art and not as mere artifacts of commercial culture."

The issue for Danto and many other philosopher-critics is the nature of the aesthetic experience embodied in Warhol's art, primarily his paintings and sculptures. In his essay "Andy Warhol's One-Dimensional Art 1956–1966" (MOMA catalog), Benjamin Buchloh argues that Warhol goes farther than both Johns and Rauschenberg, reaching "the threshold of painting's abolition." In his book, Danto takes a position that is fundamentally in agreement with Buchloh's: "What Warhol taught was that there is no way of telling the difference merely by looking. The eye so prized an aesthetic organ when it was felt that the difference between art and non-art was visible, was philosophically of no use whatsoever when the differences proved to be invisible."

Danto is suggesting that by undermining the aestheticizing eye, and thus rendering it incapable of telling the difference between art and non-art, Warhol broke down the barrier between art and life far more radically than anyone else had before

him. On the surface this idea seems acceptable. However, Danto fails to acknowledge that what lots of art and all of commercial culture have in common is a desire to escape or deny nature, which is duration and entropy. The propagandists of official art and commercial culture propose that there is an elsewhere where time stands still, even if, in Warhol's case, it's in the form of a silkscreened Brillo box sitting in the privileged space of a living room, gallery, or museum.

Danto's argument is weakened by his inability to recognize that whatever else they are, "artifacts of commercial culture" are also aestheticized objects. Just because a Brillo box is not art doesn't mean it hasn't been carefully designed. It is an item that has been packaged as an absolute necessity in the fight against entropy; and it is said to be the perfect aid for consumers in their unending battle with the forces of disorder.

The advertising departments of commercial culture never tire of telling us that everything we buy is an essential ingredient in our lives. They even go so far as to tell us why we must buy certain products. In this regard, Danto and Buchloh serve a function similar to that of the people who design commercials and advertisements. As propagandists of different brands of aesthetic thinking, they tell us why certain actions and events have been historically necessary.

If, as Danto and Buchloh assert, Warhol broke down the last vestiges separating commercial artifacts and art, was this a radical act? Or did it slyly conform to an ideal about the relationship between these two realms that was already established in their minds and those of other critics? And is this ideal concerned with the relationship between culture and nature? Or

is it focused on the links between the look of art and the look of consumer objects? In producing a silkscreened, plywood Brillo box that is indistinguishable from a cardboard carton Brillo box one sees in the aisle of a supermarket, is Warhol performing an aesthetic act or committing a radical gesture? We ought to remember that aesthetic acts are embodiments of taste, which implicitly acknowledge society's standards. They are also denials of nature.

Did Warhol undermine society's standards? Or was he repackaging them in a way that was simultaneously shocking and pleasing? Might not this combination of agitation and delight be the measure critics, as well as society, use when they bestow fame and notoriety upon artists? And if this is the case, might not their understanding of meaning be confined to the surface of the art they honor?

XV

WHAT WARHOL did not do was reveal how aestheticization, both in art and in consumer society, is a denial of facts common to us all. The subject Warhol runs from in his work is the conjunction (or division) between mind and body in their shifting awareness of time passing. The difference between Warhol and Duchamp, who is considered the innovator of an art that questions the distinction between art and life, is that the former aestheticizes everything while the latter attempts to reveal how aesthetics is an act of denial. Thus, the difference between Warhol's *Brillo Box* and Duchamp's *Fountain* is not one of degree, but one of meaning.

When Duchamp upended a urinal, signed it "R. Mutt," and placed it on a base, he was calling attention to the fact that art should not flee its roots. It wasn't the body he was pointing at, but the nature of the body as a constantly changing thing over which one has no final say. Duchamp's urinal implies that it is from this place that art and artists draw their sustenance. Warhol derived his *Brillo Box* from a cardboard carton containing packages of scouring pads. He is saying that in the end we do have control over our bodies and environment, and that we can live in a house without dirt and death.

XVI

ALTHOUGH WARHOL produced a number of silkscreened, ply-
wood boxes (Del Monte vegetables, Heinz ketchup, Kellogg's
corn flakes, and Mott's apple juice) for his exhibition at the
Stable Gallery, it is *Brillo Box* that dominates the public's imagi-
nation. *Brillo Box* is the most resonant of these works because
it embodies something the others fail to achieve. It is a meta-
phor of both itself and an aesthetic standard that began to be
accepted in the late 1940s and that proposed that the sole
purpose of art is to be about nothing but itself. Art's goal was
to keep itself pure. Warhol's *Brillo Box*, its visually perfect
mimicry of a carton of packaged cleansing pads, is an object that
the owner wants to keep clean and neat and to have look brand
new.

XVII

"WHILE WARHOL may be the most important of the Pop artists, he too draws his subjects from his own experience—that secondhand experience we all share." ("New York Pop," Lucy Lippard, included in *Pop Art*, Oxford University Press, 1970.)

Like Lippard, many critics regard the stylistic shift that occurred between Pollock and Warhol, and transpired between the mid-1950s and mid-1960s, as being concerned primarily with the aesthetic codifications of experience. In pop art, the "secondhand" world of daily life replaces the personal and private moments of the artist confronting the blank canvas, which in the minds of many is exemplified by abstract expressionism.

Out of an earlier generation's encapsulation of this shift, a younger generation of critics has proposed that the difference between modernism and postmodernism centers around the issue of originality versus repetition (a conjunction, or "doublet," coined by Rosalind Krauss). They assert that originality is a fiction rather than a fact; it is an ideal earlier generations of artists (the so-called modernists) mimicked rather than embodied. Repetition, however, is an inescapable fact of postmodern life, which the postmodernist artist recognizes and exploits. It is within this critical context that Warhol's work is seen as representative of a sea change. However, the problem with attuning one's understanding of art to the ideals of either originality or repetition is that both discourses isolate culture and its products, be they art or consumer products, from nature and its facts. Is Warhol's *Brillo Box* an acknowledgment of the world of "sec-

ondhand experience we all share"? Or does it allude to an ideal state that philosopher-critics and advertising executives, and the realms of aesthetic discourse and consumerism, teach us to believe exists? One might begin answering this question by asking who does the "we" refer to? One might also remember that Campbell's soup and Coca Cola are things and we do not experience them in the same way. For the person on food stamps Campbell's soup may be all that he or she can afford, while for the single mother it may be merely a time saver.

XVIII

ARE WARHOL'S paintings truly universal or are they sufficiently artistic? Did he reveal the emptiness at the core of consumer society or is he celebrating its legitimizing power? Is he addressing something common to us all or is he perpetuating certain myths embedded in the fabric of culture? In this century, the argument over whether a work of art is legitimate or not originates with Marcel Duchamp, best known for three very different works: *Nude Descending A Staircase*, a postcubist painting that focuses on a figure in motion rather than a still-life; *Fountain*, a porcelain urinal upended into a kind of seat and signed R. Mutt (*armutt* is German for "poverty"); and *The Large Glass*, a transparent "picture plane" that recounts the enigmatic story of a virgin bride and her nine suitors.

Critics agree that Duchamp opened the door separating art from life and privileged, elitist culture from consumer society by introducing familiar, functional objects such as a bottle rack, or what he called a "ready-made," into the nonutilitarian realm of art. According to Buchloh and others, it was this understanding of art's radical tradition that artists such as Jasper Johns, Robert Rauschenberg, and Allan Kaprow rediscovered in the 1950s. And it is their revitalization of what had been dormant for decades that eventually led to the eclipse of both abstract expressionism and the idealization of self-expression.

Within the various and by now familiar recapitulations of this narrative, Andy Warhol is seen as a central figure, the one who embodies the apotheosis of pop art and its use of "secondhand experience." The view that a younger generation of

painters shifted the focus of art from angst to machine-like repetitions between 1958 and 1962 is now so commonly accepted that many critics are content to adjust the focus slightly, like student scientists turning the microscope's dials in order to better zero in on the subject of the lecture. Their reports of what occurred in art in the late 1950s and early 1960s are seldom more than variations on a theme. Thus, abstract expressionists are routinely characterized as being concerned with emotions, spontaneity, sincerity, and originality, while pop artists are seen as being interested in mundane experiences, in planning or using familiar compositional designs, in articulating an impassive surface to their paintings, and in accepting the inability to do anything original. In order to demarcate this historic change, as well as establish a new hierarchy, critics have replaced Jackson Pollock (1912–1956), the existentialist hero of abstract expressionism, with Andy Warhol (1928–1987), the all-seeing voyeur of pop culture.

In his book *Stargazer: The Life, World & Films of Andy Warhol* (Marion Boyars, revised and updated, 1991), Stephen Koch defines Duchamp's work as leading to two possible paths. "The first begins in Duchamp's arch obscurantism, part of his work that culminated in the *Large Glass* in the Philadelphia Museum. That obscurantism led to a hermetic style. . . . The result at its best produced a sumptuous surface on which meaning was significantly refused. Duchamp Path Number One led to Jasper Johns."

Koch goes on to say that "The Second path—a parallel one—moves from Duchamp's wise-guy wit, from the moustached Mona Lisa and from his bottle rack and urinal as

sculpture, through the opposite of hermeticism. It passes through absolute legibility. Here the picture surface discloses its meaning instantly. But it is the afterglow of the instant that matters here. For Path Number Two leads to a special region where cynicism and naivety cannot be distinguished, where populism and romantic decadence merge. That is, it leads to Warhol."

Using Johns and Warhol as examples, Koch implies meaning is either something the artist refuses to disclose or it is instantly understood. This suggests that meaning can only be located in one of two places, either on the painting's surface or in some shadowy zone beyond the realm of the viewer's understanding. However, isn't "absolute legibility" the result of an agreement between the artist and the public? Hasn't the meaning of the work already been decided upon? And might not the accepted reading mask another meaning that is latent in the work?

Did Warhol, as Koch proposes, pick up where Duchamp left off and set out in a new direction? Or is there a knowing, though overly simple, agreement between Warhol's work and Duchamp's, which enables critics to posit the former is the latter's heir? If art conforms to an external definition of what it should be like, doesn't this agreement between a specific work and theories about art (one could substitute "poetry" for "art") imply that the artist is an assimilationist, and that he or she wants to make work that has its place in someone else's narrative? Might not Warhol (and he is certainly not alone in this) have consciously set out to make work which conformed to some accepted definition of radical and new? And in doing so,

didn't Warhol perpetuate the legitimacy of certain aesthetic theories and views, something that critics have failed to recognize because it is in their best interests to be blind about their own complicity in these matters?

XIX

INSTEAD OF leading to "hermeticism" and "legibility," as Koch claims, Duchamp's work embodies an unpredictable intersection of experience and aesthetics. Lodged inside a bird cage, a pile of sugar cubes carved out of marble, for example, raises questions about the relationship between appearance and identity. What we see is not what we get. In order to discover the nature of the sugar cubes, the viewer must investigate the contents of *Why Not Sneeze, Rose Sélavy?*, 1921. Looking at it is not enough. Viewers must overcome their aestheticizing eye and experience the work in a way that combines their physical, visual, and mental capacities. However, the accepted readings of Duchamp's work focus on aesthetic issues and ignore the viewer's experience when engaging his work. In *Why Not Sneeze, Rose Sélavy?*, Duchamp addresses the various ways human beings frame and aestheticize experience, both to deny their awareness of mutability and to ignore the relationship between what a thing is and what it looks like. Duchamp's work makes us aware of a choice: Either we live in the world of appearances or we choose to plunge into the realm of experience. The former offers the illusion of comfort, while the latter promises nothing.

The difference between Johns and Warhol may be discerned from their analyses of Duchamp's work. Like Duchamp, Johns investigates the realm of experience, the *during*. In his painting *Flag*, 1954–1955, he frames the relationship between identity and appearance by underscoring the fact that something that looks like a flag is not necessarily a flag. Thus the viewer begins by recognizing the image of the "flag," then

moves beyond the realm of a familiar and thus repetitive experience to discover what is specific about the identity of Johns's *Flag*, its conflation of image and thing. In the end, the viewer discovers that *Flag* may look like a flag, but its unique identity is determined by the integration of its materials: encaustic, color, brushstrokes, newspaper collage, and stencils. *Flag* undermines our understanding of the realm of "secondhand experience." Johns's implicit hope is that we will become aware that, however similar things are in the world of mass production, each thing is actually unique.

In his painting *S&H Green Stamps*, 1962, Warhol repeats the same image of a stamp coupon in order to evacuate the experiential space of art until there is no during, only what Koch calls "legibility." With *S&H Green Stamps*, the viewer moves from seeing to recognizing, from before to after. And having reached this state of after, the viewer realizes that seeing consists of recognizing an image that has been repeated hundreds of times. In actuality, S&H Green Stamps are a form of substitute money (Warhol also painted dollar signs and dollar bills). The recipient of the coupons is entitled to make certain purchases from a guide. The items are generally of low quality and function as carrots for the consumer. The whole scheme is to lead the shopper to believe that while he or she is buying groceries (necessities), they are also obtaining coupons which they can use to obtain a luxury item (a toaster or TV). In effect, S&H Green Stamps promise something more for your money; they are tickets to the after.

This state of after is still operative in better-known paintings such as *Marilyn* × *100*, 1962, where the contrast between

the left- and right-hand sides of the painting does not lead to discovery on the part of the viewer. Rather, the viewer notices the misalignments between areas of color (yellow for hair, red for lips, and blue for eye shadow) and Marilyn's face on the left or the various ways the black ink has heightened or blurred her photographic image on the right. These differences are effects, and in that regard *Marilyn* × *100* parallels paintings of color field artists—the stained canvasses of Helen Frankenthaler, Morris Louis, and Jules Olitski come readily to mind. Like their work, *Marilyn* × *100* is poetical, but it isn't poetry.

XX

IN 1960 Johns made two sculptures, both entitled *Painted Bronze*. The first of them, *Painted Bronze* (Ale Cans), is a bronze sculpture of two Ballantine ale cans, one open and empty and the other closed and presumably full, which have been screwed into a bronze base. Each can has been painted in a way that corresponds with its actual counterpart. In examining the work more closely, the viewer discovers that the cans are neither exactly the same nor are the differences between them the result of the artist's expressive decisions. The open can is slightly smaller than the closed one, and its top bears a three-ring sign (the company's logo) and the word *Florida*.

Johns's sculpture embodies the artifacts of someone drinking alone. He or she has paused between what has been finished and what has not yet been started. Together, as something open and consumed and something closed and unconsumed, the cans frame the way one experiences continuous time or what is called the now. Rather than being in the now, an individual experiences it in terms of past and future, memory and desire.

At the same time, like all art, Johns's sculpture exists in the meanwhile—the timeless realm that parallels ours, where a painting or a sculpture is a moment forever frozen. However, what *Painted Bronze* (Ale Cans) does not do is make the meanwhile into an elsewhere. Johns uses the meanwhile of the sculpture's existence to investigate his relationship to time. In *Painted Bronze* (Ale Cans), Johns reveals the way one makes the now into separate blocks of experience. For us, living between what we have done and what we have yet to do means existing

in a space that is after and before. It is this understanding of time that the meanwhile of *Painted Bronze* (Ale Cans) so succinctly embodies.

Johns's decision to use bronze makes it clear that he is emphasizing the links between the timelessness of art and the constantly changing physical world. Bronze comes in a solid form, which is then heated until it becomes liquid. After it is poured into a mold, it cools and solidifies. In the realm of art, bronze's solidity is considered permanent, while in the world it may only be temporary. *Painted Bronze* (Ale Cans) consists of two ale cans, one solid and the other hollow. The solid one is waiting to be used, both as a can of "beer" and as a bronze cylinder, while the contents of the hollow one have been "poured" out. Thus bronze's two states, solid and liquid, are underscored by the cans of "beer." The permanent, Johns seems to be suggesting, may only be temporary, and there is a larger cycle of time that art will probably not escape.

At the same time, in order to underscore our philosophical disconnection from mutability and experience, Johns has integrated a material that embodies cyclical time (or nature) with his analytical perception of the way we categorize finite human time into states of either after or before. *Painted Bronze* (Ale Cans) is a metaphor for the relationship between the artist and art making. When the artist is not making something, he or she exists in the realm between the after and the before, which can be seen as the introspective moment of having finished one can of beer and waiting to start another. Instead of being in the world, *Painted Bronze* (Ale Cans) suggests one is forever between things.

In his conflation of bronze and two cans of beer, Johns recognizes that the cycle of bronze from solid to liquid to solid again echoes, as well as frames, both the body's inevitable dissolution and the mind's attempt to ignore this fact. Bronze is able to return to its original state of being solid, while for the body there is no return: there is only change and departure. Johns indicates this passage in time with two cans of beer, their evocation of the body metamorphosing because of its absorption of alcohol. Although *Painted Bronze* (Ale Cans) is the first time Johns used something with a commercial logo, it is neither an act of displacement nor one of appropriation. Rather, Johns has transformed his perceptions of the self in time into a sculpture. By choosing two objects that embody his perception of the self in time, Johns makes a sculpture that is neither an expression of the "I" nor a pure work of art. In fact, *Painted Bronze* (Ale Cans) challenges both the modernist ideal of originality and the postmodernist model of repetition.

Johns's sculpture may not be, as Koch says of Warhol's work, instantly "legible," but it does disclose its meaning. However, by characterizing Johns's work as "hermetic," Koch continues what by now must be called the traditional way of reading his art. One reason for this misguided tradition is the critics' inability to address art that is experiential. They prefer the comfort of aesthetic theories because these discourses consist of attempts to codify and escape nature and time. This is one reason why critics have for more than three decades repeatedly failed to come to terms with the latent meanings of Johns's work.

A recent example of this tradition of self-satisfied misun-

derstanding of Johns's work was espoused by Adam Gopnik, who states that throughout his career Johns "has been pulled between a natural gift for mystery and an acquired bent for mystification." Substituting "mystification" for "hermetic," Gopnik concludes his essay with: "His achievement, in retrospect, has been to show that you can have a beautifully cerebral art that contains absolutely no ideas at all." ("Jasper's Dilemmas," *The New Yorker*, February 1, 1993.) What a relief. We no longer have to think about Johns's work because he is an empty-headed artist who doesn't have any "ideas at all": we can just look at it for its beauty. The possibility that Johns's art is not about thinking but about living seems to have completely escaped Gopnik's aestheticized perceptions. He approaches art the way a glutton looks at a leg of lamb: it is something to consume and appreciate, not reflect upon and consider.

In the painting *Before and After*, 1960, which was probably influenced by Johns's *Painted Bronze* (Ale Cans), Warhol transferred the image of a cheap newspaper advertisement for plastic surgery onto a large canvas. Done in black and white, the painting depicts two images of a woman's profile. The one on the left has a large hook nose, while the one on the right has a correctly proportioned and therefore beauty-enhancing nose. Warhol's approach to the now of continuously changing time is to divide it, as the painting's title indicates, into before and after.

The differences between *Painted Bronze* (Ale Cans) and *Before and After* run deeper than the formal categories separating a sculpture from a painting. Johns's sculpture seamlessly integrates physical and visual properties. The viewer looks at the

sculpture's painted surface and at the same time becomes aware of its tactile presence. In *Before and After* Warhol used synthetic polymer, a nontactile, water-based medium, to articulate the image of a woman's profile. In one panel she is conventionally ugly, and in the other she is typically attractive. Although *Before and After* is an early work in Warhol's career, doesn't it tell us something about his attitude toward the idealization of beauty? Certainly it is difficult to see this painting as a critique of the ideal of beauty since it gives equal weight to the states of before and after. The implication is that one can move from the before to the after, from a state of unwanted ugliness to the preferable realm of beauty, without experiencing the during.

By dividing the now into the before and after, Warhol is suggesting that we can stand outside of time, that there is an elsewhere or after that can be reached. This attitude is the very opposite of the one Johns takes in *Painted Bronze* (Ale Cans), where he has framed the now into the after and before, thus suggesting that we cannot escape time, however hard we try. Johns not only exposes the common structures underlying much of our daily perception, but he also shows the viewer how he or she tries to frame experience into discrete units. Warhol does the opposite: he mirrors the illusions society wraps around itself.

The profiles in *Before and After* are not defined by lines, but are contours made up of dark and light, each mapping the distance separating its bodiless existence from that of the ideal. Although it is possible for a line to articulate an edge, and thus evoke the volume behind the edge, a contour depends on the viewer's recognition rather than being a means of discovery. In

Before and After, not only are all references to the body absent from the painting, but the painting reproduces a contour, which is a means of tracing the body's escape from itself and gravity.

It is the bodiless presence that Warhol continues to focus on in the paintings of Marilyn Monroe, Elizabeth Taylor, and Jacqueline Kennedy that he did in the mid 1960s. They are not portraits so much as images made up of flat colored areas and photographic contrasts derived from the media, and as such named the level of their fame. In moving from *Before and After* to the faces of famous people, Warhol was stressing that fame is the after that each of us seeks. Warhol's insistence on the importance of appearances and images, as well as his attempt to be both timely and to stand outside of time, is a constant factor throughout his career. In this regard, Warhol's art adheres to the aesthetic standards of its time and is no more radical than any other art that conforms to academic standards. And like all academic art, from the warm pink bodies of Bouguereau to the rosy-cheeked workers of Otto Nagel, Warhol's paintings propagate the notion that there is an elsewhere that is readily attainable.

The attitude connecting the images that Warhol used during the early 1960s is his assertion that the before and after is something that can be controlled. Among the characters he transferred from comic strips to paintings are Superman, Batman, and Popeye, three seemingly ordinary individuals who possess the power to transform themselves into superhuman forces. Along with the newspaper ad for cosmetic surgery, Warhol also chose an advertisement for wigs and a cure for foot ailments. The body was something one could control and

change, like Zeus turning into a swan.

In the mid-1980s, when Warhol was in his mid-fifties, he did a painting, *Over 40*, 1985, in black and white, which recalls *Before and After*. Derived from an ad, *Over 40* depicts the frontal view of a woman's face. The left half has gray hair, while the right half has black hair. Graphically arranged above this image are the words, OVER 40, HOW YOU CAN GO FROM THIS TO THIS. In *Before and After*, Warhol disguises his desire to change his appearance by appropriating an ad for cosmetic surgery for women. Twenty-five years later, he conceals his fear of growing older by reproducing an ad for hair coloring.

Warhol's repeated presentation of the before and after can be contrasted with Johns's insistence on representing the state of during, which he frames with evidence of the after and before. Warhol attempts to break down experience into what precedes and follows its occurrence. For him, there is no now, no during. He valorizes stasis rather than acknowledging his own unavoidable passage through time. Warhol was a voyeur; he wanted to believe death and old age happened to other people, but that in his case he could control or deflect it. At the same time, his relentless concern with appearances registers the degree to which he felt uncomfortable with himself, with who he was and with the way he looked. He was someone whose looks made his skin crawl, who needed to wear a wig and had had a nose job.

Johns's approach to experience takes a different tack. He wants to discover and articulate the shifting bonds between the self and the world. For him, there is the now that is constantly changing. And that change is something he recognizes the body is undergoing even as the mind may defer or deny it. It is his

perception of this state of metamorphosis that Johns attempts to embody in his work. He knows the mind can try to ignore time's consequences, but it and the body cannot escape mortality. Johns looks at what is inescapable, while Warhol attempts to convince himself and the viewer that it is possible to obliterate time, make it stand still forever. It is this negation of experience that connects Warhol to commercial culture; both propose there is an elsewhere or after that can be obtained.

The work of Johns and Warhol constitutes very different attitudes toward the relationship between art and life and in this regard can be seen as representing divergent aspects of both modernist and postmodernist art. Since the late 1940s, when Clement Greenberg asserted that art's sole purpose was to be about itself, there has been an ongoing argument between those artists who flee nature and those who attempt to discover where and how culture and nature intersect. The artist who successfully withdraws from nature into a realm that is purely aesthetic agrees in principle with the ideals and categories established and maintained with bureaucratic fervor by much of the art world. These artists place their work at the base of one of the official monuments to aesthetic theory. In this sense, Warhol was an assimilationist who wanted his work to be accepted by the purveyors of art and academic discourse.

XXI

JOHNS's *FLAG* and *Painted Bronze* (Ale Cans) are simultaneously physical and visual. They are things that underscore the bond between appearance and identity, between surface and substance. Throughout his career Johns has tried to map the topography of the place wherein exists the union of the face and body of a thing; and this union refocuses one's awareness of experience rather than locating one's perceptions solely within the confines of aesthetics. It is this desire to glimpse wholeness that is central to his art.

For Warhol, identity is something to be ignored or suppressed. Better the face than the body of a thing or an event. He is concerned with a thing's appearance, which he proposes is more important than its identity. By being attentive to the world of appearances, Warhol accomplished two seemingly disparate goals at once. He acknowledged the idealization of necessities developed and marketed by consumer society, and he paid homage to the critical dicta of what modern art should look like in order for it to be considered new and avant-garde. This is where modern criticism and commercial culture share an interest. Both are concerned with the look of a thing. For them, identity, which in contemporary art is difficult to categorize, is relegated to a lesser status.

In his art, Warhol does something other than underscore the vacuousness of modern life. He clarifies the emptiness of almost all brands of contemporary criticism, the wrongheadedness of those commentators who love or hate his work because it either fulfills or fails their ideals. Warhol's work reveals that

what both the judgmental establishments of the art world and the legitimizing institutions of profit-making businesses are primarily concerned with is perpetuating the importance of appearances. Each creates the myth of the elsewhere, which in art means (depending on your stance) transcendence, an emptied now, the death of art, the demise of originality, or the world of the after, and in consumer society is the realm of beauty, success, happiness, and fame. Ezra Pound's dictum "Make it new" has been replaced by business's credo "Make it look new" and by the aesthetic measure "Make it look new enough."

XXII

IF ART is a matter of solving problems such as how to utilize the design aspects of repetition so that a work of art looks new enough, then postwar American artists have a lot in common with American automobile manufacturers. Not only have they designed something that has little in common with the actual world, but, once they believed they had solved certain problems, they began thinking that the only thing they had to do each year (or art season) was change the look of their products. The people who claimed these artists made works that were historically necessary, that they were proof and definition of the historical time in which we existed, were the counterparts of those who managed the automobile ad campaigns, the ones who told the public that buying a Corvette, Edsel, Thunderbird, or Eldorado was necessary if one wanted to be truly alive and free.

XXIII

THE FOUNDATIONS of modernist criticism began to take root nearly fifty years before the death of England's monarch Queen Victoria, in 1901. In a footnote in his book *The Elements of Drawing*, which he wrote in the winter of 1857–1858, John Ruskin asserted: "The whole technical power of painting depends on the recovery of what may be called the innocency of the eye: that is to say, of a certain childish perception of those flat stains of color, merely as such, without consciousness of what they signify, as a blind man might see them if suddenly gifted with sight."

It is worth noting that when John Ruskin got married, he was dismayed to discover his wife, Euphemia Gray, had pubic hair and sued for an annulment because their marriage was never consummated. It seems the way she looked when she was naked did not correspond with the classical and neoclassical statues of young, smooth-skinned, marble nymphs with which Ruskin was familiar. He preferred the unblemished realm of aesthetics to the messy domain of human experience and tried to reside in a world ruled by an innocent eye.

Ruskin gained his reputation when, at the age of twenty-four, he published his five-volume *Modern Painters* (1843). In the first volume, Ruskin set out to interpret the work of J. M. W. Turner, an artist whose work was both discredited and neglected at the time. While Ruskin's reevaluation of Turner helped a new generation reappraise his work and make it famous, Ruskin later tried to control what was known of the artist's work by destroying various sketches by Turner that he

felt were pornographic. A highly secretive man, Turner was known to wander the English landscape for months at time, with no one knowing his whereabouts. Ruskin, as executor of Turner's estate, had access to the artist's studio after his death and learned that during his wanderings Turner would frequent brothels, where he did numerous watercolors of both the prostitutes and clients. These works not only undermined Ruskin's representation of Turner, but they also challenged his belief in the realm of the innocent eye. It is this realm that critics since Ruskin have continually attempted to map and rule.

It is worth noting that modernist critic Clement Greenberg, in his role as one of the executors of the sculptor David Smith's estate, deliberately altered some of Smith's work because he believed they were more sucessful as "unpainted" sculptures than as painted ones. Thus, in their roles as critics, Ruskin and Greenberg have actively censored the work of artists they supported. Might we not want to reconsider those artists whose works these men dismissed? Might not their dismissals be a form of censorship?—something the art world supposedly abhors.

Ruskin's paradigm of the innocent eye was taken up by Clive Bell in his book *Art* (1914), in which he stated "lines and colors combined in a particular way, certain forms and relations of forms stir up our aesthetic emotions." One, of course, does not give a name to these emotions; that would be too vulgar. In 1967, in his article "Complaints of an Art Critic," Clement Greenberg extended the arguments of Ruskin and Bell and proposed that "anything in a work of art that does not belong to its 'content' has to belong to its 'form'—if the latter term

means anything at all in this context. In itself 'content' remains indefinable, unparaphraseable, undiscussable."

Content, it seems, is not accessible to discourse or speech. In order to achieve this state of silence, art has to embody a realm that is simultaneously legible and nonnarrative. This mystification or, some have argued, demystification of art was an ideal artists as diverse as Andy Warhol and Frank Stella attempted to support in their work. It is these standards the shrill prose of critics like Schjeldahl attempts to uphold.

During the 1960s, Stella coined a slogan many of his contemporaries took to be an unchallengeable truth: "What you see is what you see." Content, form, and meaning were taken in by the viewer all at once. Andy Warhol's own remarks echo Stella's: "If you want to know all about Andy Warhol, just look at the surface of my paintings and films and me, and there I am. There's nothing behind it."

If we accept that content and meaning, like the final name of God, are indefinable and undiscussable, then we are meant to look at the art of Warhol, Stella, and, more recently, Schnabel and be mystified. The power of universal art is such that viewers are overwhelmed by its very presence in their lives. This enlightening paralysis is further encouraged when the artist uses repetition or the grid, as did Warhol and other artists during the 1960s. By defining both the content and meaning of repetition or the grid, postmodernist critics, like their modernist forebears, were able to absolve themselves of their responsibilities. Like priests and priestesses, they could in certain matters invoke the vows of silence they had taken.

In her essay "The Originality of the Avant-Garde: A Post-

modernist Repetition," Rosalind Krauss revises as well as continues Greenberg's bureaucratic proscriptions regarding content: "The grid thus does not reveal the surface, laying it bare at last; rather it veils it through repetition." Although Krauss replaces Greenberg's notion of modernism with her views of postmodernism, she still upholds the view that content, form, and meaning are indivisible. For her, the grid shields itself through repetition.

Confronted by large paintings that make use of the grid, Warhol's *Marilyn × 100*, for example, the viewer is meant to be speechless. This is the correct way to look at the painting. Any remark or content that breaks the spell of aesthetic emotions would be a sign of the viewer's lack of taste. According to Krauss, "This silence is not due simply to the extreme effectiveness of the grid as a barricade against speech, but to the protection of its mesh against all intrusions from outside."

A realm that cannot be intruded upon by speech, which is evidence of the realm of human affairs, is one that can also be defined as universal and Edenic. In this century it has been a much-fussed-over Eden, where the tasteful gather and silently reminisce about the glorious past, gaze respectfully at the edifying present, and pray for a stable and illuminating future. In her esssay "The Prints of Andy Warhol" (*The Prints of Andy Warhol*, Flammarion, 1990), Riva Castleman wrote: "In other words, Warhol's commentary on culture was found in his choice of souvenirs; and with his *Myths*, *Ads*, and a series called *Cowboys and Indians* he portrayed nothing less than the universal view of America's once enchanted and powerful past." Although these prints do not utilize the grid, Castleman believes they are uni-

versal enough in their appeal to induce a state of respectful silence in the viewer. Thus Krauss, who advocates a postmodernist view, and Castleman, who upholds a modernist outlook, are in fundamental agreement when it comes to discussing the meaning of art. They have concluded that a painting or work of art can be discussed only in relationship to their view of art history and what they assert it can and cannot mean. In this regard, Castleman, Krauss, Buchloh, and Danto belong to different teams of a debating club.

Ruskin's Eden of the innocent eye upholds the notion that it is best when the artist and viewer can become children untainted by the world of experience and memory. It is in this place of purity that content and meaning become extraneous. We are meant to look at Warhol's *Cowboys and Indians* and discuss neither content nor meaning, which Castleman asserts is "universal" and thus immediately legible and edifying.

At the same time, according to Krauss, we are to recognize that repetition and the grid are frontal attacks on the fiction of originality. This counterview suggests that Warhol used repetition and the grid because he was concerned with art history and aesthetic theory (its views of what constitutes modernism and postmodernism), rather than with universal themes. Contained within Krauss's notion of the grid is her belief that we all exist in a period when, in order to expose the fictions upheld by the Eden of the innocent eye, we must duplicate its surface, its images of Marilyn Monroe and Mickey Mouse.

In both cases, however, it is the surface appearance of the art that matters most and whether or not the work fulfills the critic's aesthetic theories and definitions regarding the look and

thus meaning of modern art. The cliché "Don't judge a book by its cover" seems to have gained little credibility in the art world. Yet if one believes appearance can be separated from identity and experience, then one is in effect tacitly agreeing that racism and sexism are legitimate forms of recognizing someone who does not correspond with one's ideals. Whether modernist originality or postmodernist copy, the myths of beauty that culture continually revives are forms of denying, as well as speaking for, the other. This is an issue mainstream critics and aestheticians from John Ruskin on have managed conveniently to ignore.

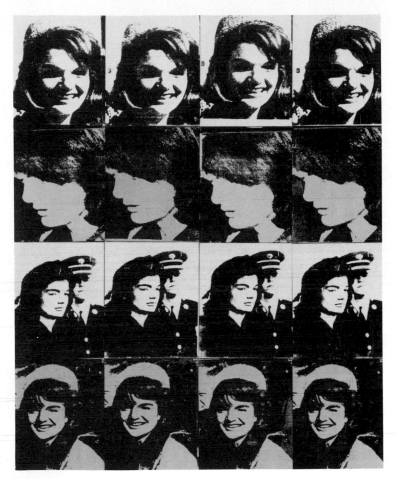

2

1

3

4

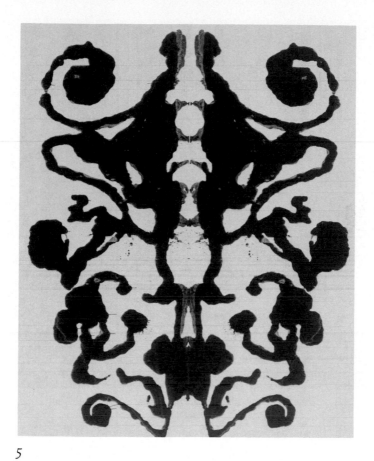

5

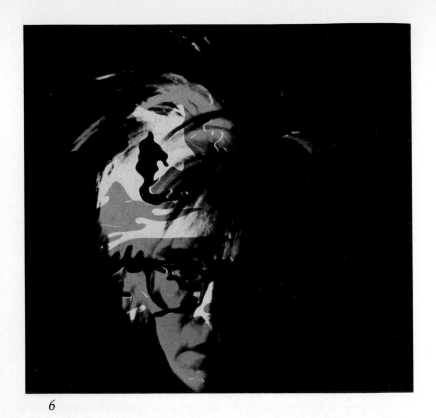

6

7

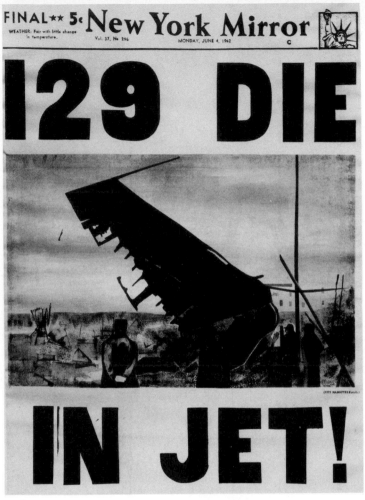

8

XXIV

MIGHT NOT the end of history and the abolition of painting simply be a sign of the critics' frustration that the old rules of assimilation no longer hold and the next set of ideals has yet to be formulated? Might not these solemn proclamations be a final, desperate defense thrown up against the growing awareness that certain narratives of history, whether concerned with defining modernism or postmodernism, have been losing their validity from the moment they were first told? Might not all these new proposals be the latest set of arrogant attempts to assert America's dominance of the wider cultural landscape? Might not they be forms of censorship disguised as criticism?

For those who construct the art world's standards, this must be an immensely frustrating moment. They have power but are unsure how to legislate it. No doubt some individuals and institutions will appear to be reexamining the old standards and offering new ones. They will try to convince the public they are righting old wrongs. However, the issue will not be whether the new standards are new or not, but whether they, like the old standards, make denial an official and efficient program for looking at art.

XXV

THE ARTIST as innocent child, as either someone uncontaminated by the world or someone so contaminated by pop culture all he or she can do is mimic it, has been a central motif of postwar criticism. In the years of modernism, the artist's task was to make pure art. Postmodernists have asserted that originality and purity are fictions. They celebrate the artist who rephotographs the photographs of others, as well as the artist who buys lava lamps and prosthetic devices and places them on a shelf for the way they illustrate the historical moment, which is the death of the author and the triumph of commercial culture's definitions of meaning over any possible authenticity. The innocent child has become the obedient student, hands raised in the air, answer to the question on the tip of his or her tongue. Good students believe their parents' dictum: "Do it because I say it's good for you." Good students know if they follow the critics, who play the role of substitute parents, they will get their just reward. After all, the critics have told them that "One day you will thank me for this."

XXVI

THE PROBLEM with the accepted readings of modern art is best illuminated by the way John Cage's 4'33" has been characterized. A musical composition in which a pianist sits down at a piano, opens it, but doesn't play it for the concurrent lengths of times that add up to the amount specified in the title, 4'33" has been cited as a neo-dadaist gesture, a celebration of the death of music, proof of Cage's failure as a composer, and a trivializing act. It is really something else. While critics have described 4'33" as a piece of silent music, it is a length of time the listener can never hear the same way twice. Instead of hearing music, something that can take the audience to the elsewhere, we listen to ourselves listening to the world we inhabit, something we don't ordinarily do.

It is a mistake to characterize the surface of Cage's 4'33"— its lack of musical notes (not notation, as he pointed out)—as the locus of the experience. If you read the surface as silent, as silence, you are proposing that 4'33" lacks all signs of life. If this were actually the case, it would be something we couldn't actually experience. Cage's 4'33" is the very opposite of silence; it directs us toward what Tennyson called "noise of life."

XXVII

"EMPIRE IS an eight-hour film of the Empire State Building, seen from the forty-fourth floor of the Time-Life Building from late dusk until early morning." (Patrick S. Smith, *Warhol's Art and Films*, UMI Research Press, 1986.) The viewer doesn't have to see Warhol's film to know what transpires. The camera is stationary and documents the slowly changing light or, perhaps more accurately, darkness. The film is shot in real time and the principal actor (Warhol is supposed to have said: "The Empire State Building is a star!") does nothing. The building's presence is continuous and temporal. It is the environment that alters only slightly.

Warhol uses the camera's unblinking eye to lock the audience into a single point of view, thus echoing the static, tightly cropped, silkscreened image of the star's face he placed in the center of *Gold Marilyn Monroe*, 1962. By evacuating the during of the film, which many believe is an integral feature of the medium, to the extent that he does, Warhol is able to configure the audience's experience into a before and after. As in the paintings, where the viewer is shown that recognizing equals seeing, the audience of *Empire* recognizes that the camera is focused on a familiar landmark and begins to wait for something to happen. The result: an uneventful *now*.

In another film, *Couch*, Warhol filmed people—hangers-on, his "superstars," and whoever else wanted to participate—doing whatever they wanted to on a couch in his studio. The stationary camera was pointed at them, like an

all-seeing eye. According to Smith there are more than fifty reels, each around thirty-five minutes long. In *Couch,* the during again becomes a test of how long one will wait to see something happen; the camera's fixed position is synonymous with that of a Peeping Tom, standing completely still so he won't be noticed and thus disturb whatever is about to happen.

Empire is an eight-hour movie in which almost nothing happens, while *Couch*, in more than fifty reels, offers the promise of something unexpected happening. Both films equate seeing with a voyeur's necessary endurance. In an interview with Smith, Emile de Antonio "recalled viewing one reel in Warhol's studio in which a prominent socialite freely fornicated." De Antonio's discreetness about the socialite's identity is telling; the voyeur must wait patiently in order to discover what will transpire. Until something does, he or she exists outside of time and change.

In comparison with Cage's *4'33"*, *Empire* muffles the "noise of life." Warhol's Campbell's soup cans define experience as the similarity between seeing and recognizing, while films such as *Empire* collapse seeing and recognizing, and the before and after, into a static now. The during one might think is intrinsic to film itself is denied. Time, it seems, can be made to stand nearly still. Both *Empire* and *Couch* challenge the voyeur's self-imposed patience.

The view of the world *Empire* holds up to the audience can be characterized as the point where recognition becomes synonymous with experience. One can imagine seeing the film

without ever having gone to it. This is not the case with $4'33''$. Warhol points his camera away from the during, while Cage directs our attention to it. The former dulls our awareness of experience; the latter heightens it.

XXVIII

THROUGHOUT HIS career, Warhol tried to empty the during of time and metamorphosis. He wanted voyeuristic innocence and infinite stasis to be the standard measures of experience and of looking at art, because they conformed to the prevailing critical attitudes. A close follower of the art world, particularly when it seemed to be changing in response to Johns's first solo exhibition at Leo Castelli Gallery in 1958, Warhol was more than likely aware of the first review of the exhibition to be published in *Art News*, January 1958.

In it, the painter Fairfield Porter, echoing Ruskin's notion of the innocent eye, wrote of Johns: "He looks for the first time, like a child, at things that have no meaning to the child, yet or necessarily. What meaning they have may be irrelevant to his absorption in looking." A figurative painter, Porter asserted the importance of a quasi-mystical union between artist and the work of art. Porter's view continues the critical myth about Pollock and the abstract expressionists, that their paintings are signs of unmediated expressions of the pure self. In Johns's work, however, a shift is said to have occurred. The work is no longer the product of the self but the result of an unthinking innocent who took his designs from common objects and familiar things. This is simply the application of a theory and it tells us nothing about the latent meaning of Johns's art. It wasn't pure art, but Porter, Robert Rosenblum, and others read it according to their ideals of purity. In doing so, they laid down the foundation for a tradition of misreading Johns's work that has persisted for the past thirty-five years.

Rather than reading Johns's work for himself, Warhol listened to what others misguidedly said about it. He began painting the way he did in 1960 in hopes that he would be accepted by Johns and the artists associated with him. It wasn't the first time he wanted to be accepted by someone else nor would it be the last. Warhol was alternately publisher of *Interview*, which was a trendy gossip magazine with no real gossip, avant-garde filmmaker and friend of the "stars," novelist, philosopher, photographer, painter, host of his own TV show, and an artist who could include images of a "Plains Indian Shield," "John Wayne," and "Geronimo" in the same portfolio of prints. Right from the beginning of his career in commercial art, Andy Warhol wanted to be all things to everyone. In one of his final groups of paintings, the "Rorschach" series, 1984, he tells the viewers that they can see whatever they want in his paintings. In moving from the Campbell's soup cans of the early 1960s to the "Rorschach" series of the mid-1980s, Warhol goes from upholding the idea that what you see is what you see to what you read into it is what you read into it. Warhol's timely shift from the modernist realm of the innocent eye to the postmodern realm of everything is valid suggests the price he (and others) paid to be a darling of the art world; like a good butler or child, he would do what he was supposed to do, which was to be peripheral, but necessary.

XXIX

ANY ACCURATE recounting of postwar American art will have to examine the kinds of dances that routinely occurred between proscriptive critics and obeisant artists, the celebrations that took place as a result.

XXX

WARHOL ACTED disinterested and purposeless when that was what was called for in the 1960s. In the 1970s he did society portraits because that was where the money was to be found. In the 1980s, he connected himself to young artists who believed what critics had said about him: that he was the most famous and perhaps most important postwar American artist. He also did various series of paintings and prints that were targeted for certain markets. Thus the "Vesuvius" series was shown in Naples (Italy), "Ten Portraits of Jews of the Twentieth Century" in Coral Gables (Florida), and portraits of sports figures in Los Angeles. In each phase of his career Warhol was an assimilationist, someone who did what he thought would get him accepted by those he believed were more successful or, if not that, more wealthy and more powerful than he. He was good at targeting his market. He was someone who couldn't forget that he was the son of immigrants and had to prove himself. This need was the job he never knew how to leave.

XXXI

ALTHOUGH WARHOL is a pop artist, Donald Judd a minimalist sculptor, and Peter Halley a neogeo abstractionist, what they have in common is their desire to deny both the passage of time and the inevitable metamorphosis of every identity. In the aestheticized realm of appearances (one could call it the perfumed palace of culture), change does not occur and time is an abstract concept. In the modernist era this meant the realm of timelessness was accessible; in the postmodern era it has meant the death of timelessness. Critics tell us that we have moved from the Eden of pure art to the prison of fakes, copies, and effigies. Whether as citizens of Eden or of Mammon, Warhol, Judd, and Halley are propped up as royalty, and Johns is someone no one understands, a monk or alchemist who is concocting a private language. In this regard, Johns is one of the most dangerous of all the artists, because what his work means challenges not only every accepted reading of it, but the philosophical foundations of those readings. Warhol, Judd, and Halley willingly subscribe to the Platonic-Aristotelian tradition; Johns does not. Warhol upholds the fictional spaces of before and after; Judd asserts that the before and after are the same, an eternal presence; and Halley insists we are all imprisoned in the same after. Johns, however, tries to embody the facts of living in the space between the after and the before. It is not Coca Cola and Campbell's soup cans that we have in common; it is that we are all stuck in time.

XXXII

JEFF KOONS is among the art world's leading contenders for the
Duchamp-Warhol crown. Nearly everything he does seems to
be news. In his review of Koons's show, which appeared in *The
New Yorker* (May 18, 1992), Adam Gopnik wrote: "The news
that Ilona Staller, or La Cicciolina ('Italian porn star and politi-
cian,' as she is always called), was separated from the artist Jeff
Koons reverberated all around the twelve square blocks of my
downtown neighborhood a couple of months ago—the last
little aftershock emanating from Koons's 'Made in Heaven'
exhibition, at the Sonnabend Gallery, which had been the ritual
outrage of the contemporary art season."

One wonders why Gopnik feels it is necessary to tell the
reader he lives in SoHo, near the galleries. Is he reporting the
news or identifying himself as one who is successful enough to
live in the right part of town? Like Schjeldahl and Rose, Gopnik
is a gossip who wants the reader to know how close he is to the
scene (obviously near the middle of it, given his address). He is
too busy advertising his fashionable neighborhood to recognize
that the image of La Cicciolina—"Italian porn star and politi-
cian," as he is so mindful to repeat—is a parody of feminine
types the mythmakers of culture have associated with Marilyn
Monroe and Jackie Kennedy, and thus embodies deep-rooted
anxieties about the roles women can take in contemporary
society. A woman can be a porn star, politician, or politician's
wife because in each of these roles the public sees her as serving
the desires of others. However, she cannot be both a self-
determining and self-defining individual. Koons's assumption of

the fundamentally sexual, dependent nature of women—a view also shared by David Salle and Eric Fischl—is an inextricable part of his misogynistic response to the changes women have demanded of society and its hierarchies.

Elsewhere in his review, "Lust for Life," Gopnik writes: "When Andy Kaufman, who could be Koons's twin, did the routine where he would wrestle with a woman from the audience in order to demonstrate women's 'inferiority,' you genuinely did not know whether he believed what he was saying or not. He probably didn't know, either, and that is what made the routine interesting (and creepy)." Gopnik's ideal of the artist (or comedian) as innocent or out-of-it child sounds like another version of the "Twinkie" defense. Gopnik takes this stance—How can we talk about the meaning of Koons's work when he himself isn't sure what he means—in order to get himself off the hook. Ever the score keeper, Gopnik points out that he was the first to suggest that Koons was a "nut," as if that characterization tells the whole story. He goes on to say: "The old Warhol-soup-can question—did the person who did this intend it ironically or not—has been replaced by a new question: Does the person who did this even know what irony is?"

In pointing out the lack of self-reflection on Koons's part, Gopnik not only recapitulates Warhol's assertion that the meaning is all on the surface of a painting, sculpture, or film, but he also continues the ideal of the artist as innocent child. In Koons's case, the innocent child is a "nut," while in Johns's case, he is someone with no ideas at all. One has the feeling that Gopnik, like many other critics before him, cannot accept the possibility that the artist is a being capable of both thinking and doing, and

may in fact know something that he doesn't. This would grant the artist the same rights as a thinking and doing critic.

At the same time, Gopnik believes "Koons is out there passionately expressing himself, as full of feeling as Kirk Douglas in *Lust for Life*." Gopnik is like the art world's cleaned-up version of Warhol; a high-minded ironist, as well as a detached observer, he likes to watch Koons do his "weird" thing. As in the case of any "nut," how the specific manifestations may be read as symptomatic of society's ills, as well as those of the individual, is of no interest to Gopnik. Gopnik's twelve-square-block neighborhood isn't tainted by something as humdrum as life and madness.

Koons's early works, that is to say, the things preceding his silkscreen photographs and sculptures (from small to monumental and done in porcelain, glass, and polychrome) of him and his wife, Cicciolina, having sex, have been described as either critiques of contemporary society's commodification of all feelings, actions, and things, or as complicit support for the notion that every state of being is defined by market-driven products. If, as some critics assert (and Koons's work seems to support these proposals), we buy all our emotions and self-images in the form of things, then the suggestion is that we have become nothing more than reflective surfaces, mirrors of the economic class we inhabit. We possess dual citizenships: Eden and Mammon.

In an essay written on Koons, "We Don't Need Another Hero: Aspects of the Critical Reception of the Work of Jeff Koons" (*Jeff Koons*, San Francisco Museum of Modern Art, 1992), Brian Wallis isolates and underscores three competing

readings of Koons's work by four critics (Hal Foster, Kirk Varnedoe, Adam Gopnik, and Judge Richard Cardamone). In his reading of the "art historical interpretation," which was articulated by Kirk Varnedoe and Adam Gopnik, curators of *High & Low: Modern Art and Popular Culture* (Museum of Modern Art, 1990), Wallis points out that in "their careful taxonomy of what constitutes high art and what differentiates it from low culture," Varnedoe and Gopnik "served mainly to reify the separateness of the two fields." Wallis reminds the reader that for Varnedoe and Gopnik, mass or "low" culture is always "alien and unwelcome." He goes on to point out that "designated as 'high' culture, Koons's works were exhibited in a manner befitting modernist sculptures: as individual, purist, purposeless, formal objects." By bringing items from low culture into the realm of high art, Koons enables elitists such as Gopnik and Varnedoe to show how much appreciation they have for the world of the masses. They are dumb but entertaining. Such thinking once characterized white society's attitudes toward blacks, or male attitudes toward women.

Like Warhol's *Brillo Box*, Koons's best-known sculpture, *Rabbit*, 1986, a stainless steel cast derived from an inflatable toy, can be read as a metaphor for the artist. Like Warhol, Koons has an aversion to both dirt and his body. In 1979–1980, he began encasing vacuum cleaners in Plexiglas boxes. In the catalog accompanying his San Francisco retrospective, he stated: "The thing I like about the vacuum cleaners is that it's a kind of androgynous appliance." Koons's "androgynous appliance" can be read as a projection of the artist's self-image, which is that of a self-contained yet greedy machine-like entity, a metal penis

with an avaricious mouth. In 1985, he suspended basketballs in hermetically sealed tanks of water. Around this time, he also cast bottles of liquor, life rafts, aqualungs, and skin diving tanks in stainless steel or bronze.

Critics see all these works as acts of displacement, and thus resonant echoes of Warhol and Duchamp. This is their surface or formal meaning. It's like a marching song we heard in camp. We know the tune but fail to listen to the words, to what they are telling us. The issue is not the surface meaning, but the latent one. What Koons is displacing is more than a thing; he is feverishly articulating his displaced or unengaged self. What is common to these works (vacuum cleaners, skin diving tanks, basketballs, cast liquor bottles in the shape of cars) is that they are containers of dirt, air, and liquid: shit, flatulence, and piss. This act of withholding is best exemplified by the *Rabbit*, whose highly polished surface (skin) would be marked if a viewer touched it. Thus a hands-off, highly sensitive, decoratively bright, industrially tough skin is used to encase air.

Koons's *Rabbit* proclaims its erotic sensitivity and passive resilience, rather than a gluttonous, machine-like sexuality. Koons's choice of a rabbit is not only a coy hint about the power of his sexual drive, but also a nod to society's eroticization of children, of individuals who do not possess the power to resist. The coyness is what makes it endearing to the audience. It is a monument to a helpless infant having a tantrum. It announces its extreme sensitivity by holding its breath. *Rabbit* casts into art the moment when the androgynous (or sexless) erotic infant chooses to hold its breath rather than cry out, because it knows the latter action will engender anger rather

than feigned concern. It wants to be cuddled, not scolded. The meanwhile *Rabbit* embodies is the desire for endless attention, as well as constant recognition. Koons's art arises out of the need to appeal to others. He wants to seduce the viewer into liking him. He craves their approval because they possess the power to justify his actions.

In this century we have moved from artists who draw like children (Picasso and Pollock) to the hypersensitive child proclaiming his difficulty adjusting to the demands of the big, bad world (Warhol and Koons). The pleasure the art world must feel in the presence of Koons's work is a secret one. They are happy that an artist would go to such an extreme to prove to them that he is hopelessly infantile. They feel entitled to the little *frisson* of shock and pleasure that Koons's work gives them. Like doting parents, they rush to reward him, while pretending to wonder and worry about what he will do next. Secretly, of course, they want to see how far he will go to get the carrot. For them, it is a true luxury. Here is a pampered child they can finally and justifiably lock in the closet when they get sick of his antics. At the same time, the longer the art world defers real criticism, which is neither rejection nor praise, the more it can pride itself on being open-minded and understanding; and, like Koons and Gopnik, the more it remains disengaged from the world it inhabits.

Koons (the overindulged but hardly innocent child) is received and rewarded by the art world (the worrying, doting but hardly loving parents) because both high culture and mass culture want to celebrate their "bad boys," as well as continue their nostalgia for the ideal of a young man sowing his wild

oats. An artist, preferably male, must do something that makes him both notorious and famous, must do it in a way that mimes the viewer's desire to break taboos. Koons is the kind of male child both the art world and commercial culture prefer because even though he is spoiled, he is also ambitious and productive. In this regard, he is no different than either the CEOs and real estate barons who buy his work, or the curators and critics who lavish him with praise. One of the reasons Koons's work appeals to Gopnik is because he sees in it a reflection of his own narcissism.

XXXIII

ONE IS and then one changes into what one wants to become: a fireman, an airline pilot, a nurse, a lawyer, or a movie star. Since childhood many of us have been told this is the basis of the American dream (that it's often an entitlement for the privileged and a nightmare for the disadvantaged is something the art world has refused to address until recently, and now largely in a superficial or cosmetic manner). In Eden or the American dream, we can move from the before to the after we most desire. This is one of the meanings underlying Warhol's work, starting with the various *Before and After* paintings, and continuing until his death. In later works such as *129 Die in Jet* (Plane Crash), 1962; *White Car Burning III, 1963*; and *Little Electric Chair,* 1965—the "Death and Disaster" paintings—Warhol reveals another facet of his denial of the during. Instead of the during, which is what Cage, Duchamp, and Johns investigate in their work, Warhol replaces the during with a legible now, which is really the after.

While Warhol culled from the pages of tabloids and newspapers a number of images he used in his "Death and Disaster" paintings, he also had access to glossy, press agency photographs. These photographs were more disturbing in their explicit violence than most of the ones found in the newspaper. The shock of the images is unmistakable, and their graphic nature should remind us that the era of news photographers such as Weegee started to wane in the late 1950s. Warhol was probably also familiar with Weegee's book, *Naked Hollywood*, first published in 1953, in which the photographer attempted to

penetrate the public's misconceptions of Hollywood. Stardom was, however, a misconception Warhol continued to uphold with much success.

Might it not be instructive to pair the images of Weegee and Warhol in an exhibition? A closer examination of their representations of various events and individuals may reveal much about how the newspaper functions in bringing the public news of Hollywood, murders, car accidents, and suicides. One thing would become clear: Weegee had to overcome the disadvantages of working in the newspaper medium, its grainy images and display of various, conflicting images, while Warhol used silkscreens, a larger scale, and color to enhance what are in many cases already startling images. This is not to say one is better than the other, but to delineate the formal restrictions one worked under and the other was able to exploit.

Warhol's "Death and Disaster" images are located in the zone where culture's voyeurism and nature's facts intersect. However, instead of depicting the before and after in a single composition, Warhol places the viewer in the privileged space of the after. We are both the bystanders and the survivors, the ones who see what has happened to others and go on with our lives.

In the "Death and Disaster" paintings, Warhol equates glancing through a newspaper with going to a museum. Both take up a few minutes of the day. In neither instance are we meant to reflect upon what we have experienced, because each is a variation upon a comforting routine. Most of us will never directly experience an electric chair or a plane crash; these are things and events we recognize but do not know. Through the

use of a familiar format, Warhol is able to transform the untimely and perhaps gruesome death of someone into an abstraction. Grief, horror, chaos, and violence are distilled into an illustrated story. Facts are turned into theater; a newspaper is a ticket to a bunch of inexpensive plays. And if we are aesthetically sensitive enough, we can pretend to look and listen for the first time. However, the question we might wish to ask ourselves, one that is aesthetically insensitive, is whether or not the newspaper and thus Warhol's images have the ring of truth to them. Or are both purporting to show us a truth we are ready to believe?

The people in the paintings—the man jumping from a window, the couple who have crawled out of their overturned car, the two women who have died from eating contaminated tunafish—inhabit an endless after. They are the faces of an event rather than the body (or bodies) in it, the appearance of death rather than death itself. One can take a kind of childish glee in knowing that he or she is a bystander untouched by what has occurred. This is the aestheticized space that exists between the viewer and Warhol's paintings. His work establishes a boundary we do not have to cross since what we are meant to see is the image, the appearance of the thing, rather than the thing itself. Warhol's "Death and Disaster" paintings are a series of bodiless events.

In *Big Electric Chair*, 1967, Warhol uses deep reds and blues to define an electric chair. It resembles a chair one might see in a dentist's office or a barber shop and sits in an otherwise empty room. The room's illusionistic space has been flattened by both the contrasting bright colors and the photographic image. It is

not a space we can see ourselves entering, but it is an image we can leave behind, on the wall of a museum. The bright colors do not invite the viewer to move closer to the painting and begin examining it. Warhol aestheticizes the electric chair, makes its potential power over an individual into something harmless and pretty.

In repeating horrifying images, as he does in *5 Deaths 17 Times in Black and White*, 1963, and *Orange Car Crash 14 Times*, 1963, Warhol obliterates the during of these images even more. This denial of the during is also a feature of an early movie, *Sleep*, 1963, which is seemingly a "real time" record of a man sleeping (another kind of death). In actuality, *Sleep* was spliced together from many loops of film. As in the "Car Crashes" series, Warhol uses repetition in order to destroy any curiosity we might have in the now of time and change. By making viewers see time as something endless and unchanging, he provokes them to leave the theater and seek the elsewhere. If, however, we stay and watch ourselves watching the film, we become voyeurs whose rewards are small at best. In *Sleep*, Warhol, the self-hating voyeur, turns his passive rage against the viewer by making him or her undergo his experience of the world. By transferring his experience to ours, Warhol is able to overcome his feelings of difference, as well as justify to himself that everyone is the same. He makes us see through his eyes.

Juxtapose *Sleep*, the experience of watching the poet, John Giorno, sleeping (fluttering eyes, slow breathing) with *Green Disaster #2*, 1963, a silkscreened painting that consists of two adjacent rows of the same image (a man sprawled out of a wrecked car) stacked six high, and one senses that Warhol

possessed a hands-off curiosity, as well as disgust, over the world, particularly as it manifested itself as change, dissolution, and chaos. He wanted to be outside of time, but, and this became much more evident when he began doing celebrity portraits, he hated the fact that he was an outsider. Thus, in his early paintings, he would divide experience into the before and after, and the outside and inside, while in early movies such as *Empire* and *Sleep* he undermines any sense of now with images that repeat themselves, like a metronome. In doing so, Warhol raised the practice of Chinese water torture to the level of aesthetic experience, as well as taking us inside the mind-set of a self-loathing Peeping Tom.

XXXIV

Sonnet for Andy Warhol

Zzzzzzzzzzzzzzzzzzzzzzzzzzzzzzzzzzzzz
Zzzzzzzzzzzzzzzzzzzzzzzzzzzzzzzzzzzzz
Zzzzzzzzzzzzzzzzzzzzzzzzzzzzzzzzzzzzz
Zzzzzzzzzzzzzzzzzzzzzzzzzzzzzzzzzzzzz
Zzzzzzzzzzzzzzzzzzzzzzzzzzzzzzzzzzzzz
Zzzzzzzzzzzzzzzzzzzzzzzzzzzzzzzzzzzzz
Zzzzzzzzzzzzzzzzzzzzzzzzzzzzzzzzzzzzz
Zzzzzzzzzzzzzzzzzzzzzzzzzzzzzzzzzzzzz
Zzzzzzzzzzzzzzzzzzzzzzzzzzzzzzzzzzzzz
Zzzzzzzzzzzzzzzzzzzzzzzzzzzzzzzzzzzzz
Zzzzzzzzzzzzzzzzzzzzzzzzzzzzzzzzzzzzz
Zzzzzzzzzzzzzzzzzzzzzzzzzzzzzzzzzzzzz
Zzzzzzzzzzzzzzzzzzzzzzzzzzzzzzzzzzzzz
Zzzzzzzzzzzzzzzzzzzzzzzzzzzzzzzzzzzzz

Ron Padgett
ca. 1967

XXXV

DIDEROT MADE a distinction between an art that was dramatic and one that was theatrical. Warhol whetted the public's appetite for the theatrical. In this regard, he was popular culture's descendant of their condescending version of Pollock ("Jack the Dripper"), as illustrated by the photographs of him painting, which were published in *Life*. It was the photographs that made Pollack both famous and notorious.

XXXVI

ABOUT HIMSELF, Warhol said: I'd prefer to remain a mystery; I never like to give my background, and anyway, I make it different all the time I'm asked. It's not just that it's part of my image to tell everything, it's just that I forget what I said the day before and I have to make it up all over again. I don't think I have an image anyway, favorable or unfavorable.

I never understood why when you died, you just didn't vanish, and everything could just keep going the way it was only you wouldn't be there. I always thought I'd like my tombstone to be blank. No epitaph, no name. Well, actually, I'd like it to say "figment."

Machines have less problems. I'd like to be a machine, wouldn't you?

Everybody has their own America, and then they have pieces of a fantasy America that they think is out there but they can't see. When I was little, I never left Pennsylvania, and I used to have fantasies about things that I thought were happening in the Midwest, or down South, or in Texas, that I felt I was missing out on. But you can only live life in one place at a time. And your own life while it's happening to you never has any atmosphere until it's a memory. So the fantasy corners of America seem so atmospheric because you've pieced them together from scenes in movies and music and lines from books. And you live in your dream America that you've custom-made from art

and schmaltz and emotions just as much as you live in your real one.

I still care for people but it would be so much easier not to care. I don't want to get too close; I don't like to touch things; that's why my work is so distant from myself.

XXXVII

ABOUT ART, he said: I like to be the right thing in the wrong space and the wrong thing in the right space. But when you hit one of the two, people turn out the lights on you, or spit on you, or write bad reviews of you, or beat you up, or mug you, or say you're climbing. But usually being the right thing in the wrong space and the wrong thing in the right space is worth it, because something funny always happens. Believe me, because I've made a career out of being the right thing in the wrong space and the wrong thing in the right space. That's the one thing I really do know about.

You should always have a product that has nothing to do with who you are or what people think about you. An actress should count up her plays, a model should count up her photographs, and a writer should count up his words, and an artist should count up his pictures so that you never start thinking the product is you, or your fame, or your aura.

I suppose I have a really loose interpretation of "work," because I think that just being alive is so much work at something you don't always want to do. Being born is like being kidnapped. And then sold into slavery. People are working every minute. The machinery is always going. Even when you're asleep.

The reason I'm painting this way is because I want to be a machine. Whatever I do, and do machinelike, is because it is what I want to do. I think it would be terrific if everybody was alike.

XXXVIII

ABOUT THE differences and similarities between being a commercial artist (ca. 1949–1959) and being an artist, he said: I was getting paid for it and did everything they told me to do. If they told me to draw a shoe, I'd do it, and if they told me to correct it, I would—I'd do anything they told me to do and correct it and do it right. I'd have to invent, and now I don't; after all that "correction," those commercial drawings would have feelings, they would have style. The attitude of those who hired me had feeling or something to it; they knew what they wanted, they insisted; sometimes they got very emotional. The process of doing work in commercial art was very machinelike, but the attitude had feeling to it.

Why do people think artists are special? It's just a job.

XXXIX

WARHOL REPEATEDLY expressed the desire to become a machine, but had he been able to get his wish he might have chosen to be one that kept score. He was always aware of who else was in the room and, in the 1970s, which of them he wanted to have commission him to do their portrait. On September 27, 1978, he told his friend and diarist, Pat Hackett, to list the following events:

5:30	Roberta di Camerino's at "21"
6:00	Barney's for Giorgio Armani
6:30	MOMA for *Rolling Stone* anniversary
7:00	Cocktails at Cynthia Phipps's
8:45	Dinner at La Petite Ferme
10:30	Joe Eula's party
11:00	Halston's
12:00	Studio 54 for an animal benefit
1:00	Flamingo's for tit-judging party that Victor arranged for me to go to.

In order to maintain his aura, Warhol was compelled to attend as many events as possible. He had to see who else was there, as well as be seen by others. If he was lucky, one of the gossip columnists would report his whereabouts the next day. He once told Bob Colacello that they could leave a party they had just arrived at because they had been photographed, and that was proof that they had attended the crowded gathering. In September 1978 he described going to Polly Bergen's house: "Polly's

house is very modern and well decorated. There were *Architectural Digests* everywhere. And her dressing room looks like a department store, with racks of blouses and skirts and dresses and gowns, and she has a telescope that's for looking at stars, but she uses it to look at stars' houses, and we looked into Danny Thomas's house across the canyon, but nothing was happening there except a few geraniums were growing." Reading this, one wonders if Polly Bergen was there.

Warhol's description makes him sound like a forensics expert looking for clues at the scene of a crime. He was always checking out other people, particularly if they were famous. At Bergen's house he scanned the magazine racks, poked around in her dressing room, and looked through a telescope to see if there was anything good and hot out there. It was as if he were a Peeping Tom waiting for something to happen.

■

XL

WARHOL WANTED to paint portraits of Gala Dali, Imelda Marcos, and Nancy Reagan, but because of their vanity they wouldn't let him. In Imelda Marcos he saw "the single commission that miraculously multiplied ad infinitum." (Bob Colacello, *Holy Terror: Andy Warhol Close Up*.) If she consented to having her portrait done and then liked it, she could order others for the lobbies of banks, post offices, train stations, official residences, government buildings, and embassies around the world. After Imelda Marcos, Warhol turned his attention to Her Imperial Majesty Empress Farah Diba of Iran and was able to get what he wanted: a commissioned portrait that led to more. In Marcos and Diba, he thought he saw what he must have wanted since childhood: a bottomless piggy bank.

XLI

MARILYN MONROE died on August 5, 1962, while Warhol was in Los Angeles for his exhibition at the Ferus Gallery. Shortly after he returned to New York, he began using a publicity still of Monroe from *Niagara* (1953) as an image in his paintings. The particular image, which Warhol chose and cropped, refers to the moment Monroe became a star. *Niagara, Gentlemen Prefer Blondes,* and *How to Marry a Millionaire* were all released in 1953, as were a series of 1948 nude calendar photos that had appeared in the debut issue of *Playboy*. By the end of the year Monroe had been voted top star of 1953 by American film distributors.

In 1962–1963, Warhol also chose images of Jackie Kennedy, Natalie Wood, and Elizabeth Taylor. Natalie Wood had starred in the 1955 Nicholas Ray film, *Rebel without a Cause* (along with other young stars James Dean, Sal Mineo, and Dennis Hopper). In 1962 Wood played the role of Maria in the musical *West Side Story*; and in 1963 she played the role of a young, innocent stripteaser in *Gypsy,* a rather tame musical about the early life and career of a vivacious, articulate stripper, Gypsy Rose Lee. During the 1950s, Lee shared a brownstone with Jane Bowles and Carson McCullers. W. H. Auden presided over their evening repasts. Theirs was a circle of friends whose existence Warhol learned of shortly after he arrived in New York but knew wouldn't accept him.

One of Warhol's Elizabeth Taylor paintings shows her dressed as Cleopatra. During the filming of *Cleopatra,* which was one of the most expensive movies ever made, Elizabeth Taylor

got severely ill and nearly died in a hospital in Rome, something Warhol documented in his painting, *Daily News, 1962*. Another painting from that year, which referred to Taylor's marriages, was *The Men in Her Life (Mike Todd and Eddie Fisher)*. Todd, we might recall, died in a plane crash. In 1960, Taylor won an Oscar for her role as a disillusioned call girl in *Butterfield 8*. In 1963, when *Cleopatra* was finally released, Warhol did *Blue Liz as Cleopatra*. That same year he also did a painting, *National Velvet*, in which he repeated an image derived from a cropped publicity still of an adolescent Taylor on a horse.

The cropping of Monroe's face, Taylor on a horse, Wood's face (it looks almost like a photo one would find in a high school yearbook), and Jackie in mourning, imprisons them further. Warhol's use of cropping, repetitive layouts, grid-like arrangements, and superimpositions deprives these photographic images of a space in which to exist. He uses the grid and repetition to acknowledge as well as trivialize their power. While the abstract space into which Warhol has placed them echoes the public's fixation with these women, it is wrong to see his use of grid simply as a tacit nod to the mass media's ability to duplicate endlessly. Warhol may have wanted to be a machine, but his machine would still have feelings, as he said about his commercial work. It is Warhol's feeling of worship mingled with vindictiveness that runs throughout his work.

Within the context of cultural myths, Warhol's choice of Jackie Kennedy seems consistent with his use of the other three. Although she wasn't an actress, she was considered a regal public figure. She was also seen as establishing a new feminine ideal for a younger generation of women, while Monroe and

Taylor were connected with an earlier ideal. Unlike these two women, her life wasn't yet subject to gossip and rumors. Rather, she was recognized as the president's devoted wife, and the images Warhol used of her were derived from photographs in the days following her husband's assassination in Dallas.

Marilyn Monroe, Elizabeth Taylor, and Jackie Kennedy: on the surface of it, it seems as if Warhol has selected three women who are bonded together in the realm of death and dying and has equated the after of recognition with the moment certain well-known figures are placed on a higher plane in the public imagination. Since 1962–1963, when public imagination installed these women on another level, their lives have been subjected to repeated scrutiny, mostly in an attempt to characterize or stereotype them further.

In this case, Warhol's use of Natalie Wood seems at odds with his other choices. Like Taylor, she gained attention as an adolescent. However, unlike the other three women, she hadn't yet had a brush with mortality. Finally, Wood's life wouldn't become the subject of gossip and speculation until she died mysteriously while swimming off her yacht in 1981, two decades after Warhol painted her.

One reason Warhol's portrait of Natalie Wood has never gained as much attention as his paintings of Monroe and Taylor is that he did many more works using images of the latter two. It may have been that he quickly recognized Wood's image didn't embody the whore/goddess contrast to the same degree.

Born in 1938, Wood made her screen debut in *Tomorrow is Forever* (1946), and starred in the comedy fantasy, which some consider an American classic, *Miracle on 34th Street* (1947). Until

1963, and *Gypsy*, Wood had played the role of virtuous heroines and neurotic young women in films such as *Rebel without a Cause* (1955), *Marjorie Morningstar* (1958), and *Splendor in the Grass* (1961). *Gypsy* may have suggested flagrant sexuality, but it was at best a miscast musical that tried for comedic effects rather than telling a dramatic story. By the time Warhol painted her, she had starred in roles that embodied the honest child, the loving misunderstood daughter, the honorable young woman, the heartbroken girlfriend, and the sex object. However, of all the movies in which Wood had starred, the one that probably motivated Warhol to use her was *West Side Story*. In that film her boyfriend, Tony, is killed. Thus Wood is an embodiment of the femme fatale. It is this role that connects her to Monroe, Taylor, and Kennedy.

Marilyn Monroe had been married to Joe DiMaggio, the baseball hero of New York's working class, and Arthur Miller, the darling of the New York's intellectual and literary circles. She was the sex object who sang at President Kennedy's birthday celebration, which was held at Madison Square Garden. President Kennedy represented a shift in power from an older, more sedate generation to a younger, more vigorous one. He was seen as bright, sexy, and tough, while Jackie embodied a new feminine ideal for the 1960s. When President Kennedy was assassinated, Jackie became in Warhol's mind a femme fatale. She and Taylor formed the real-life counterparts of Wood's Maria: all three were beautiful young widows. Joe DiMaggio and Arthur Miller didn't die when Monroe left them, but their images were badly damaged, and she was subsequently perceived as a destroyer of men.

Elizabeth Taylor went from personifying innocence in *National Velvet* to playing the role of a selfish, sluttish queen. The images of Taylor in *National Velvet* and as a "blue Cleopatra" are mirror opposites, while the image of Monroe's face in the middle of a gold ground can be read as mirroring itself. All three portraits echo society's idealizations of women. The gold ground evokes Byzantine icons and remoteness as well as gaudiness and availability. These dualistic views are consistent with the repressive images of women as either goddesses or whores. Taylor's roles as innocent adolescent and scheming Cleopatra are presented by Warhol as two sides of the same coin: the innocent virgin and the worldly queen.

As Thomas Crow points out, "Monroe and Taylor were nearly equal. Each maintained her respective position by a kind of negative symmetry with the other, by representing what the other was not." He goes on to say that "Warhol elaborated on the contrast, beginning with its dramatic confrontation of light and dark, and that duality opened a productive vein in his work through 1963 (as opposed to his dead-end experiments using male actors such as Troy Donahue and Warren Beatty)." ("Saturday Disasters; Trace and Reference in Early Warhol," *Art in America*, May 1987.) Crow's observation, however, doesn't go far enough, partly because he not only fails to deal with Warhol's choice of Wood, but also because he restricts himself to formal or surface analysis. It was more than Monroe being a blonde and Taylor, Kennedy, and Wood being dark-haired that motivated Warhol to use their images in his work. This view suggests that Warhol was more interested in their appearance than in the sexual roles he believed they embodied. However,

it is the ideal, one which society in its packaging of these women helps construct, that attracted Warhol's attention.

Warhol's choice of Marilyn Monroe, Elizabeth Taylor, Jackie Kennedy, and Natalie Wood is based on the stereotypes they were perceived by the public to embody. They had been or were childlike, queenlike, sexually innocent, innocent and sexual. They had been cast in the position of girlfriend, wife, mistress, call girl, and stripper, all roles requiring a male. Whether in life or on film, each woman embodied the power of a femme fatale.

Warhol took literally the ideal of femme fatale when he chose Jackie Kennedy as a subject. In *Sixteen Jackies*, 1964, which consists of four rows of four images each, the top and bottom rows show Jackie smiling. Death has interrupted her life, but not ended it. *Sixteen Jackies* depicts the survivor, while *The Men in Her Life (Mike Todd and Eddie Fisher)* depicts Taylor with the husband she survived and the man she will marry, who at the time was married to Debbie Reynolds, a blonde. Later, Fisher left Reynolds, who had just given birth to Carrie Fisher. In *Daily News*, 1962, Warhol chose as a subject the newspaper headline: EDDIE FISHER BREAKS DOWN. The subheadline read: "In Hospital Here; Liz in Rome." Even when Taylor is on the point of death, she possesses the power to destroy a man.

Warhol saw these women (and, one senses from this, all women) as possessing a dualistic nature. His strong attraction/repulsion motivates him to locate his subjects within a cycle of death and sexuality. As images derived from photographs and then silkscreened onto the canvas, they are either bodiless or drained of substance. *Gold Marilyn Monroe* is an image em-

balmed, while the misregistration of lipstick and lips in *Green Marilyn*, 1964, *Red Jackie*, 1964, and *Early Colored Liz*, 1963, hints at the inevitable decay of their fleshly counterparts. Each is comparable to the image of an old vain woman who can no longer put on her lipstick "correctly." They are garish mirrors of the future Warhol anticipated all women, if they lived long enough, would one day inhabit.

Warhol saw women and paintings as synonymous; both were effigies. Within this context, his images of women during the 1960s, and the methods of representing them and other insiders that he reprised in his social portraits of the 1970s and 1980s, compels us to go beyond celebrating him as a trenchant social observer of contemporary culture and to recognize the degree to which he shared with many others certain fears and anxieties about women. And within this context Warhol is correctly perceived as setting the precedent for Jeff Koons, David Salle, and Eric Fischl. All four express feelings of awe and disgust toward women; and within their work they articulate their belief that the relationship between a man and a woman is an endless struggle for power.

For *White Burning Car III*, 1963, and *Saturday Disaster*, 1964, Warhol chose images that are grotesque mirrors of his portraits of Kennedy, Monroe, Taylor, and Wood. *White Burning Car* repeats the image of a man impaled on a climbing rung of a telephone pole and hanging above an overturned, burning car. His arms extend down stiffly and out at an odd, slightly raised angle, recalling the robotic motions of Boris Karloff in *Frankenstein* (1931), while his head looks down, like Christ on the Cross. The conjunction of Frankenstein's monster and Christ

isn't as unlikely as it sounds when we remember that Warhol was, as many of his friends have pointed out, a faithful church-goer as well as an ardent movie fan.

In 1962–1963, when Warhol began using images of Monroe and Taylor in his paintings, he also chose a film still of James Cagney in *The Public Enemy* (1931) for *Cagney*, 1962, and one of Bela Lugosi in *Dracula* (1931) for *The Kiss (Bela Lugosi)*, 1963. Warhol's choice of Lugosi brings to mind one of his nicknames, one that associates called him behind his back, which was "Drella." The film still Warhol used in *The Kiss (Bela Lugosi)* shows the creepy Transylvanian count about to plunge his fangs into Helen Chandler's exposed neck. She has fainted from fright. The image of a vampire about to feast can be read as a metaphor for Warhol's approach to subject matter as well as his view of intimacy, which was either a loss or gain of control. Through his use of photographs, silkscreen techniques, cheerless color, repetition, and the grid, he was able to effectively drain the body and face of substance and turn his subjects into copies, ghosts, effigies, and images. In his portraits, Warhol defined painting as a combination of cosmetics and embalming.

In *White Burning Car III*, a man is visible in the distance, behind the accident. He is walking past the scene, not looking either at the accident or toward the viewer. In *Saturday Disaster*, Warhol repeats a close-up of a car, its door wide open and nearly ripped off its hinges. One victim lies sprawled perpendicular to the car, while the other is frozen in a pose reminiscent of an Olympic diver preparing to jump into a pool. The lower part of his body rises up, while the upper half dangles down, almost perpendicular to the prone victim. One of the diver's

hands is between the prone victim's spread, twisted legs, while his head rests beside his crotch. A row of bystanders, all looking elsewhere, is visible behind the car.

Warhol wants us to look at what we would rather avoid and what he himself is drawn to see over and over again, like a kid who has installed himself in front of his television set and who is waiting for something to really happen; the death of others. *Saturday Disaster*, the seemingly descriptive title of the painting, can also be read as Warhol's comment upon intimacy and friendship. In his eyes, it is better to stay home alone and watch than to go out and be with someone else: it is better to be able to switch the channel than give up the power of control.

In both of these "Death and Disaster" paintings, Warhol enlarges and repeats scenes that the viewer finds both spellbinding and hideous. The embalmer is also the reviver, the one who makes the dead resemble the living. *Saturday Disaster*, its compression of death and sexuality—which is Warhol's parody of necrophilia, which is in itself a grotesque parody—complements his embalmed, bodiless *Gold Marilyn Monroe*. *Saturday Disaster* also embodies Warhol's view of intimacy, which is one dead man making love to another.

Done in the same year, *White Burning Car III*, which shows a dead man, and *Sixteen Jackies*, which shows the survivor, are unlikely twins. While the images of John F. Kennedy being shot while riding in a car in Dallas and Jackie Kennedy crawling out the back of the moving car burned themselves deeply into the public consciousness in the days and weeks following the assassination, Warhol's response was not typical of all viewers. Fascinated and repulsed, he couldn't pull himself away from

them. However, instead of registering his feelings of reverence and grief, admiration and sadness, Warhol painted *Sixteen Jackies*, which is his view of the real culprit. She, like the bystander in *White Burning Car III*, survives. The difference is that she was in the car, rather than outside. The youngest son of a poor, working-class family, Warhol desperately wanted to gain admittance to bourgeois society. The women he chose to depict had achieved the status he so prized. Whether on film or in life, all had been femme fatales.

XLII

MARILYN MONROE'S *Lips*, 1962, is a two-panel painting, one with the lips in black and white, and the other with red lips on a mauve ground. Warhol juxtaposes a grisaille-colored silk-screen of photographic images (the factual) with brightly colored silkscreened ones (the made-up), as if there is no difference between the two. Both panels consist of bodiless, faceless images. By collapsing fact and fiction into one, Warhol conveys his view that Marilyn Monroe, Jackie Kennedy, and Natalie Wood, like all women, possess the same power. In *Marilyn Monroe's Lips*, the viewer sees rows and rows of big, hideous, toothy smiles. This is the essence of the femme fatale's power: a vagina with teeth.

XLIII

CRITICS SEEM to lose their perspective when looking at Warhol's work. His fame drives them to exaggerate his accomplishments instead of examining his work. Many concentrate on what he did between 1960 and 1968, the year Valerie Solanis shot him. They mark this event as a turning point in Warhol's life and see his work as going downhill after that. Others argue that he was consistently great throughout his career and that his last works, particularly the self-portraits combined with a camouflage pattern and the "Rorschach" series, are among the most important works in his oeuvre.

During Warhol's retrospective at MOMA, a biographical film was playing in the museum bookstore and being sold to the public. In it, like a bully in a schoolyard daring others to top him, Robert Rosenblum solemnly announced that Warhol's self-portraits were comparable to Rembrandt's. It was one of those observations that Rosenblum and others are prone to issue as a challenge; it makes good copy, and in all likelihood they believe the admiring public soaks up this kind of stuff. Rosenblum is one of those critics who keeps reiterating that everything a famous artist like Warhol does is of such historical importance that one can barely keep up with him. His kind of criticism falls somewhere between breathless flattery and glossy promotional material.

During his career, Warhol painted portraits of criminals, transvestites, political leaders, and movie stars; he did print portfolios of endangered species, cowboys and Indians, and famous Jews of the twentieth century; he hung out with Hal-

ston, Yves Saint Laurent, Diana Vreeland, Diane von Fursten-
burg, Truman Capote, Mick Jagger, and Liza Minnelli; he did a
poster for George McGovern's doomed presidential campaign;
and later he sidled up to Jerry Zipkin, a real estate heir and close
friend of the Reagans. He made movies that are more talked
about than seen. During the 1960s, his studio, an immense space
covered in silver paint and aluminum foil that he called the
Factory, became a miniature Bohemia that was constantly being
documented on film and tape recorder. It was here the smug and
the addled of uptown society could mingle with the hip and
drugged-out groupies of downtown, while the truly superior of
both sets could swoop down and see what was worth the
picking.

In the nightly theater of the Factory, high society and
low-lifers could mix together (schmooze, sigh, and babble, take
drugs and drink, have sex) and pretend Lyndon Johnson's Great
Society was something more than a whitewash. They were the
ones being seen and heard by Warhol's ubiquitous camera and
tape recorder, not the casualties of the Vietnam War. Although
images of the Vietnam War were readily available, Warhol
made no reference to it or even to war in his "Death and
Disaster" series, which he worked on from 1962 until 1969. He
may have chosen what Neil Printz calls "topical death and
disasters," or he may have with "awful intimacy and candor,
registered important changes in society," as Schjeldahl claims,
but he was also savvy enough to know that although the
Vietnam War was becoming increasingly unpopular, it wasn't
an acceptable subject, even to the uptowners and downtowners
who were opposed to it.

In his "Death and Disaster" paintings, Warhol was a reporter who stayed away from certain stories. And the ones he did show the public—the portraits of Jackie (ca. 1963–1964) or the Birmingham race riots (ca. 1963–1964)—are seen from neither an empathetic nor a confrontational point of view. In Charles Moore's photographs of the riots, which were printed in *Life*, each of three views show the blacks as a row gathered in the distance and looking off to the side, as if they are bystanders at a parade. Between them and the photographer are the cops. It is in this position, which is out of harm's way, that the viewer is placed. It is the safe zone inhabited by a voyeur. The whole event is transpiring "out there" in America's hinterlands, and except in one instance, none of its participants come close to acknowledging the photographer's presence and, thus, ours.

Warhol's "Race Riot" paintings are hermetically sealed worlds from which nothing and no one will escape to contaminate our aesthetic experience. The one black man who is seen up close (*Little Race Riot*, 1964) is in profile and is being attacked by a dog. He is leading the "parade," and the dog and the police are following. They exist in the middle ground of the painting, between the men and women looking elsewhere and the viewer. None of the blacks are looking at the camera.

Warhol uses the picture plane in both *Mustard Race Riot* and *Red Race Riot* to establish a wall between us and them. The events are engaging, but they don't involve us directly. We are invisible bystanders who can walk away at any time. By enlarging the scale of the photographs and then repeating them, as he does with the image of the black man being bitten in the rump

by a police dog, Warhol turns an ugly moment in American history into an entertaining event laden with sarcasm. *Little Race Riot* is a combination of a small town parade and a circus, and the black man is seen as both a humiliated leader and a clown.

This disturbing combination of types echoes the image of the victim impaled on the telephone pole. It is also a slyly racist dismissal of the freedom marches led by Dr. Martin Luther King. Almost everyone in America may have been able to buy a can of Campbell's soup and a bottle of Coca Cola in 1962, but that doesn't mean they were able to go anywhere and obtain them. Although factual, these paintings (and the critics who failed to recognize this) support the fiction that in the early 1960s everyone shared the same secondhand experience. But having the money to buy a Coca Cola is not the same as either being able to go into any store or being seated and served at every luncheonette.

Like lipstick or a toupee, Warhol's surfaces hide many truths, one of which is the destructive antagonism between blacks and whites, among others, that has persisted throughout American history. Why, one wonders, do critics such as Danto and Buchloh, who claim to be influenced by Hegel and Marx, seem not to have noticed the discrepancies between Warhol's surfaces and the depths they are supposed to reveal? In the aesthetic realm that Danto and Buchloh write about, the fact that a large segment of America's citizens were deliberately barred from voting, from entering stores to obtain necessities, from being admitted to the emergency rooms of hospitals, or being able to enroll in certain public schools or state colleges is of little concern: these people's lives, after all, have no bearing

on art history. When these critics announce the end of art history or painting because it is a bourgeois activity, one wants to know if they believe they are entitled to speak for both the privileged and those who do not have any access to what the privileged take for granted.

Warhol may have picked images that purport to show us what's going in America, but they do so from a protected point of view. This is a very different attitude from the one James Rosenquist takes in his complex, many-layered, *Painting for the American Negro*, 1962–1963. Rosenquist has depicted a pair of red-rimmed glasses in the upper middle of his horizontal painting. The inside of the glasses, which no one is wearing, is facing the viewer, as if he or she is meant to try them on. The glasses' right arm penetrates the side of a black man's head, which is juxtaposed (or "covered") by a piece of cake with chocolate frosting. What does it mean to say that a black person is really white on the inside?

Rosenquist understands that one of the things separating us from them is language and how we use it to maintain these barriers. We may all share the same secondhand experience, but our comprehension of it is not the same, not in a country that practiced slavery until the 1860s, had many states that actively maintained segregation until the mid-1960s, and passed and enforced racist emigration laws from the late 1800s until the 1980s.

At the same time, to the left of the red-rimmed glasses, Rosenquist draws the red-and-blue schematic outline of a seated man (his head is cropped by the painting's top edge). His shoes are shown resting on the head of a young black man who is

flanked by the heads of other black men. In *Painting for the American Negro*, Rosenquist utilizes fragmented images, various types of representation, and juxtapositions of different styles and images to address issues of mishearing, misseeing, and misunderstanding. The painting visualizes Rosenquist's understanding of the wall of misperceptions separating blacks and whites. Like Warhol, but with a very different objective in mind, Rosenquist utilizes an assortment of formal means and techniques to absorb and represent his perceptions of race relations in America.

In the "Race Riot" paintings, Warhol speaks for the whites who are made uncomfortable by what is going on. He uses repetition and design to subordinate or comment upon the images. In *Red Race Riot*, the image of a dog facing outward has been repeated twice along the bottom of the painting, once in the upper right-hand corner, and once in the second row of images (there are four rows altogether). Here, the repetition of a specific feature transforms it into a formal barrier between the viewer and the event. By repeating or cropping certain aspects of Charles Moore's photographs, Warhol is able to make the picture plane of the "Race Riot" paintings into a transparent, unbreakable barrier. The viewer is a voyeur, and voyeurism is a privileged position.

Although first the art world and then the public considered Warhol a radical and provocative artist, he seemed to know which lines to cross and which ones to pretend didn't exist. Like a gossip columnist carefully spooning out the latest hot story, he knew how much of a *frisson* to give his eager viewers so that they would leave satisfied but would want to come back for

more. Warhol wasn't a radical, but someone who knew exactly how close to come to the various boundaries society maintains and honors. Unlike Leonard Bernstein, who naively invited the Black Panthers uptown to have tea and chat with socialites and music lovers, Warhol was hip and didn't make the mistake of drawing attention to what many of his fans and supporters were trying to ignore: America was and is a country at war with itself.

At its best, Warhol's work mirrors a small cross section of America in the 1960s. In his paintings and films Warhol erects an endless hall of mirrors in which drag queens and misunderstood waifs want to be superstars, and a dead movie actress and the president's widow are recognized by the populace as royalty. It is Camelot seen through the wrong end of a voyeur's kaleidoscope.

XLIV

Finished the year before his death, *Camouflage Self-Portrait*, 1986, consists of a green, black, and gray camouflage pattern superimposed over the artist's face. The combination is telling: Warhol wanted to fit in, to be like everyone else, and he wanted to be noticed, and singled out from the crowd. He wanted to hide, but he had to be seen. This is the paradox he could never resolve, the force that drove him from party to party and made him transfer the shadowy interior world of the voyeur to the viewer's experience of film. It is neither the American dream nor the Horatio Alger myth Barbara Rose had in mind when writing about Warhol, but it is the excruciating reality he lived. This was the role he couldn't drop and which he saw as necessary to his daily life.

Warhol wanted to be accepted by every special-interest group in the world. His success can be measured by the fact that he was accepted by so many, far more than other contemporary artists. But being accepted and even being celebrated by people, institutions, and television sitcoms such as Elizabeth Taylor, the Museum of Modern Art, and *Love Boat* (on which he once played himself) doesn't prove your work is universal. Warhol did, however, embody a very American theme: the unfulfillable wish to be loved by everyone. And, like those who try to be loved by everyone, it is not surprising that he was willing to pretend whenever necessary.

XLV

A COMMERCIAL artist who was adept at giving those who hired him what they wanted, Warhol began putting these skills to work in the art world when he saw it might accept him. According to the chronology compiled by Marjorie Frankel Nathanson for Warhol's MOMA retrospective, Warhol purchased Johns's drawing, *Lightbulb*, 1958, in 1958, the year of his first solo exhibition at the Leo Castelli Gallery. In addition to showing an early interest in Johns's work, Warhol selected a drawing that could be considered atypical. In contrast to his drawings of a "flag," which is a flat thing, on the paper's flat surface, Johns has rendered a three-dimensional object on a two-dimensional surface.

Warhol was an illustrator of shoes for I. Miller and thus familiar with the problem of depicting a three-dimensional object on a two-dimensional surface. One of his favorite solutions to this problem was to draw a broken, blotted line that depicted the shoe's profile. He may have felt a certain rapport with Johns's unconventional approach to illusionism. He may have also been attracted to *Lightbulb* because it depicts a mundane object rather than abstract signs ("numerals") or what might be seen as a symbol (American flag). After becoming a successful artist in his own right, Warhol obtained another drawing by Johns, *High School Days*, circa. 1969, which depicts a shoe as seen from above. Johns's "shoe" drawing may have recalled for Warhol his own past as a commercial illustrator of shoes.

The response to Johns's exhibition was unprecedented. His painting *Target with Four Faces* was reproduced on the cover of

Art News, which also contained Porter's glowing review. Most of the work sold, and three paintings (*Green Target, Target with Four Faces*, and *White Numbers*) were obtained by the Museum of Modern Art. The paintings were of familiar things: the American flag, targets, numerals, and the alphabet in lower case. They were done by a young, self-taught artist from South Carolina, who was (Warhol might have thought) an outsider, too. All of this caught Warhol's attention. By 1960, and after Johns's second exhibition in New York, Warhol began using newspaper advertisements as a source for images in his paintings.

This kind of relationship is not necessarily something new or even strange. Magritte saw a painting of de Chirico's in the window of a gallery while riding on a bus. He got out a few stops later and walked back. An equally powerful change took place in Tanguy's work after he saw de Chirico's paintings. Warhol didn't change as rapidly as people have claimed, but when he did it was more than a movement from one style to another. He may have been obeying Rilke's dictum: change your life. Or he may have started becoming more himself, a process that would end shortly after he completed paintings such as *Camouflage Self-Portrait*, 1986.

In 1960 he began working in two ways: paintings in black and white that had as their sources newspaper ads and others in color that were based on comic strips. He was inspired in these choices by Johns, who had used newspaper as collage materials in his encaustic paintings; their words and images were discernible beneath the wax medium. In contrast with Johns, Warhol emphasized their legibility. He then moved away from using comic strips when he found out that another young

artist, Roy Lichtenstein, had not only incorporated them into his work, but was also about to be represented by Leo Castelli.

Warhol got bored of painting each of the Campbell's soup can paintings by hand and after finishing them switched to rubber stamps and then silkscreen techniques because they were easier and faster. Shortly after Marilyn Monroe was found dead of an overdose of barbiturates on August 5, 1962, he began working on his "Marilyn" series. Finally, in November 1962, when Warhol was having his first exhibition (silkscreened paintings of flowers) at the Leo Castelli Gallery, he also had party hats in *McCall's* magazine and shoe illustrations in *Good Housekeeping*.

Is the fact that he was exhibiting paintings and having his illustrations reproduced in a magazine proof that Warhol broke down the barriers between art and life and between high art and commercial art? Or was he, like any cautious man, keeping his options open and making sure he had something to fall back on should his paintings be ignored? As a man successful in the competitive world of commercial illustration, who already commanded the esteem of others, he wanted to ensure a smooth transition between that place and the art world.

XLVI

WARHOL EFFECTED a change in art that had been brewing in America ever since *Life* ran a feature on Jackson Pollock. He made attention more important than the art. In both cases, critics focused on what the work looked like, rather than what it meant.

XLVII

WARHOL'S CLAIM that there is nothing behind the surface of his paintings or films is more than a formal assertion; it is the expression of a Peeping Tom's unrelenting fear: he will be caught and exposed for what he is.

XLVIII

DURING THE mid-1950s, while Warhol was working as a commercial artist in New York, he printed up a folder to accompany a promotional gift he made for one of his clients. Its gold-stamped text stated boldly: "This Vanity Fair Butterfly Holder was designed for you by Andy Warhol, whose paintings are exhibited in many leading museums and contemporary galleries." Warhol's claim was pure fiction. He was, to use his own vocabulary, neither the right thing in the wrong space or the wrong thing in the right space. Rather, he was inserting himself into a space that had not yet accepted him. The space that would embrace Warhol didn't exist until 1958, when Jasper Johns exhibited his encaustic "Flags" and "Targets."

XLIX

THE BID by Warhol to be accepted by Johns and the art world was part of a pattern in his life. As he claimed in his promotional brochure, he had exhibited his art, but not, as he also claimed, in leading galleries and museums. Warhol's first exhibition, "Fifteen Drawings Based on the Writings of Truman Capote," was in a rented room at the Hugo Gallery, New York, from June 16 to July 3, 1952. It was an attempt by Warhol to get Capote's attention and acceptance. Warhol had already sent fan letters filled with "star dust" to the young, celebrated novelist and had once convinced his alcoholic mother to let him into the apartment she and her son shared. (Capote's mother was in some ways her son's model. She was a social climber who changed her name from the vulgar-sounding Lillie Mae to the more respectable Nina.) Capote and his mother did attend Warhol's exhibition, but did not say anything to him. Capote's rejections and silences did nothing to dampen Warhol's obsession. He had the things Warhol wanted: fame, success, and good looks. However, Warhol had something Capote didn't have: an immigrant mother who adored him.

In 1966, after he had become famous and successful in his own right, Warhol finally got his wish and was one of the "five hundred close friends" invited to what some gossip columnists referred to as "the most exclusive and most glamorous party of the decade," the Black and White Ball hosted at the Plaza Hotel by Truman Capote. On Friday, September 8, 1978, Warhol reported to Pat Hackett that he had "had lunch with Truman. He wasn't drinking, so he was boring. I paid for lunch because he

looked like he was out of money ($60). I taped, took pictures, and then we went over to his bank, the Midland Bank. Bob McBride went home, he had an allergy. As we were walking together, someone said, 'Look! Living legends!' " In 1979 Warhol painted at least two portraits of Capote, which were included in his exhibition, "Portraits of the '70's," at the Whitney.

Warhol's interest in Capote began when he saw his photograph on the dust jacket of his first novel, *Other Voices, Other Rooms* (1948). The photograph, which showed an androgynously pretty young man with big doe eyes looking into the camera while reclining on a couch, had gained Capote notoriety outside literary circles. In nearly every review of the book, the critic felt obliged to comment on the photograph. It was the first indication that Capote had a knack for gaining attention for something more than his writing. Photographer Cecil Beaton, who first took Capote's photograph in 1949, described him as "the boy with the invitational face." Beaton's assistant was Roger Lisanby, who was a friend of Warhol. Thus Warhol might have heard about Capote from Lisanby and been intrigued by his vanity and self-confidence. Because of Lisanby, Warhol may have also felt it was possible to redefine the terms of his proximity to Capote from fan to close observer. Years later Capote himself said he had "a love affair with cameras, all cameras."

Capote was twenty-three when *Other Voices, Other Rooms* was published. It was full of overripe prose and became a cult favorite among student aesthetes. Warhol was twenty-one. Both were blond, fair-skinned men, but any resemblance ended there. In 1948, the same year Capote's novel was published,

Warhol did a self-portrait, *The Broad Gave Me My Face, But I can Pick My Own Nose*, which gained him notoriety at Carnegie Institute, where he was a student majoring in pictorial design. A controversy ensued when the painting was rejected by the majority of jurors (the German artist, George Grosz, was one of the exceptions) of the annual exhibition of the Associated Artists of Pittsburgh. This juried show, which was where the students at the Carnegie Institute first exhibited the work, had never before rejected an artist's work because its content was deemed offensive. As a result, an alternative show was organized that included Warhol's painting.

Whereas Warhol, seeing himself as hopelessly ugly, made an expressionist painting (it was influenced by the work of Jean Dubuffet) that challenges the ideals of beauty, Capote advertised his beauty by mimicking an odalisque. In a sense, Warhol and Capote were opposite sides of the same coin: a bottomless, narcissistic desire for attention. Both gestures attracted considerable attention for their creators.

A year after *Other Voices, Other Rooms* was published, Warhol mimicked Capote's pose in a photograph. In 1955, although Capote would have nothing to do with him, Warhol drew his portrait, a reprise of the infamous dust jacket, showing in a few lines a tilted, round head affecting a peek-a-boo pose. Warhol's pursuit of Capote would last until the mid-1960s, when they finally became friends. Capote's change of heart was motivated perhaps by vanity: Warhol had become famous and successful enough to be of use to the writer. He was the kind of fan others in Capote's social circle would notice.

Warhol and Capote had much in common. Both were

lonely children who wanted to grow up and be adored by bourgeois society. In their quest for adulation, they developed a knack for self-promotion and were able to be interviewed by the press, get on television, play bit parts in movies, and be mentioned in gossip columns. Feeling like oddballs and knowing they were outsiders, both developed a set of memorable affectations. Their mannerisms sent the public a mixed message: they had had to pay heavily to be admitted to the inner sanctums of high society, or they embodied a slightly repellent persona that distinguished them from everyone else; or their personalities were typical of the social world they inhabited. Their trademark affectations (silent Warhol in a silver wig or Capote making a string of nasty pronouncements in a high-pitched, southern drawl) hint at the likelihood that both men felt it was in their best interest to play the role of the court jester as well as the fool. For only by acting outrageous could they both gain the attention they felt was their due, and hide who they were.

Dubbed the "tiny terror" of high society, Capote once said: "It's as if two different people were inside of me. One is highly intelligent, imaginative, and mature. The other is a four-teen-year-old." Over the years, the public saw a slender, beautiful youth entomb his looks in alcoholic bloat; a witty articulate man become a peevish viper; a stylish writer become an entertaining talk show guest. Yet despite his acerbic tongue, Capote's fey mannerisms and southern drawl made him appear harmless, particularly since he usually preyed on other insiders. He was the guy who let the public know that not all the inhabitants in the castle were behaving and that many of them

were not only stupid, but boring. The public lapped it up.

Warhol was not, like Capote, blessed with the gift of gab. He could make quotable pronouncements ("In the future, everyone will be famous for fifteen minutes"), but he couldn't really engage in anything we might be tempted to call a prolonged conversation. That was too intimate an activity for him and something he knew he couldn't control. He was not comfortable with the give and take of repartee. Whenever Warhol was around someone else, he would take out a tape recorder, turn it on, and begin asking questions; it was his not-so-subtle way of maintaining the upper hand.

At the same time, Warhol fulfilled the philistine notion of an artist, a dumb guy who paints. But he did it with theatrical, eye-catching panache. He might not talk, but there were plenty who volunteered to do the talking for him. They would sit beside him in interviews and answer the questions: "Andy thinks," and so on. He once even sent out a look-like, Alan Midgette, to make personal appearances on the college lecture circuit.

Both men became known for undermining their mediums, painting and the novel. They blurred the distinction between high and low and between art and events we associate with mass culture. Capote called *In Cold Blood* a nonfictional novel. We might see in this designation an equivalent of Warhol's depiction of car crashes. This conflation of fact and fiction led many critics, particularly after Norman Mailer wrote *Armies of the Night* (1968), to announce the death of the novel. Busy with their pronouncements, many art critics and historians seem to have forgotten that starting in the late 1960s and ending in the

early 1970s, around the time Garcia Marquez's *One Hundred Years of Solitude* was published, many literary critics wrote articles, organized symposia, and gave lectures that addressed the question, is the novel dead or not?

Capote's horrific *In Cold Blood* is comparable to Warhol's disturbing "Death and Disaster" paintings. Both men mix artistic techniques with aspects of journalism and photography. Nothing is made up, but everything is aestheticized. Raw facts have been turned into spectacle. Readers and viewers are placed in the privileged space of the after. It is from that perch that they are able to see what has transpired. In the beginning of *In Cold Blood*, Capote describes the Kansas landscape, where two drifters will murder an entire family, as if seen from a tower or plane. He is setting the stage where the events will unfold. We are in the front row, as well as in the balcony. And we have the sensation of circling above everyone and everything else. Warhol seals his scenes into airless designs through the use of repetition, overlays, and the grid.

Capote and Warhol were fascinated by criminals because they were complete "outsiders." Capote's fascination may have led him to consciously identify with the murderers (he would later commit the literary murder of his friends in *Answered Prayers*, 1987); and Warhol's fascination with criminals may have led him to turn the vanity and neuroses of others against themselves in order to see what would happen. Edie Sedgewick, Jeremy Dixon, Steven Piven, and Jean-Michel Basquiat are some of Warhol's "superstars," employees, and friends who died from drugs before they were thirty.

Certain of their works—*In Cold Blood* and *Thirteen Most Wanted Men*—arise out of a shared compulsive interest in extreme behavior, which combined elements of destructiveness with self-destructiveness. Warhol and Capote were voyeuristic rather than empathetic; they wanted to see how others behaved and what happened to them. Capote repeatedly visited death row, while Warhol aimed his camera at sadomasochists, exhibitionists, and vain neurotics. They were attracted to individuals who in and of themselves were sensational and outrageous. They managed to successfully displace their hostility by being in the position to watch others do things that would kill them. For them, voyeurism was a form of murder.

At the same time, the glamour of insiders led each to make a portrait of a woman—Holly Golightly and Marilyn Monroe—that gained them a lot of attention. In addition to being indefatigable social climbers and dedicated party goers, they were petty, hard-nosed scorekeepers. They posed as listeners and got others to confide in them. Yet, they liked to be the center of attention. Whether hosting a Black and White Ball at the Plaza Hotel or covering the walls of the Whitney Museum with purple-and-yellow cow-patterned wallpaper, each was given to making extravagant gestures that would be reported in the mass media.

Both Capote and Warhol lived in a world of excess, where a lot of everything was never enough. Capote liked to appear on television talk shows and announce that actors and actresses were stupid. He was addicted to drugs and alcohol and was once too stoned to respond to David Frost during a live televi-

sion interview. Warhol would chew on chocolates and then spit them out, because he thought they would irritate his gallstones if he swallowed them.

Like Henry James, Capote and Warhol existed in a social milieu in which women were central though not necessarily powerful, at least not like men. It was their powerlessness, frustration, anger, shame, sense of betrayal, determination, and belief in honor that James acknowledged in his writing. However, despite the often insurmountable social obstacles they faced, the women James wrote about possessed an immense dignity and inner strength. They were not vain, like the men strutting through the hushed rooms James so lovingly described. Warhol and Capote approached the struggle for power between men and women differently. One betrayed their trust in a book, *Answered Prayers*, while the other focused on their faces and ignored their bodies and minds. Warhol's and Capote's women are parodies of the male ideal; they are goddesses, harridans, waifs, and bitches. Their proximity may prove deadly.

Nearly a month after Capote died, Warhol had Pat Hackett make the following entry in his diary: "Vincent picked up the small Truman Capote portraits I'd done for *New York*. When they saw them they said they thought I was going to do something new, but I'd done them my usual way because I thought that's what they wanted. They're going to pay a user's fee. But I don't know about these low prices I get when I do stuff for magazines, because I think of the time Carl Fischer took my picture for the *New York* cover for the *Philosophy* book—I mean, he had a whole set built, and then he had eight assistants or

something, so look how much they probably spent on *that*. So I got all worked up thinking how cheaply I work, and it made me call *Vogue* and ask them where the money they owe me was."

During the years Warhol knew Capote, he replaced the ideal of good looks, fame, attention, and success with more practical goals: the accumulation of money and things.

L

WARHOL'S FAVORITE question to ask women was: How big is his cock? Usually he started out by playing coy and saying: How big is he, you know, down there?

Like his paintings, he was full of tasteless charm.

LI

IN HIS society portraits, Warhol merged adulation and hostility with the sitter's vanity. The "eye shadow" and "lipstick" (this is true for both the men and the women) were always more than necessary. Cosmetics, the paintings report gleefully, is what these people will have to turn to when they lose their looks.

LII

WARHOL WAS the child of parents who had emigrated to America from an area in Eastern Europe known as Ruthenia, which is located in the Carpathian Mountains. His father was a coal miner who spent long periods working away from home. His mother was a housewife who was protective of her sickly, albino-complected son. For both parents, English was a second language, and one they never mastered—an unmistakable sign they were immigrants. According to Colacello, one of Warhol's relatives said: "In Europe, the Ruthenians were the poorest of the poor. We never even had a flag." Colacello also points out: "They barely had a language. Until 1914, school was taught in Magyar, the language of the Hungarian rulers. Ruthenian itself was a goulash of archaic Ukrainian and modern Slovak, with many Magyar, Polish, and even German words thrown in."

When Warhol was around six—and he was no doubt encouraged in this by his mother—he started sending fan letters and collecting autographs of child movie stars such as Shirley Temple (his first blonde alter ego?), Freddie Bartholomew, Mickey Rooney, and others. In 1934, amid a worldwide depression and the rise of fascism, Shirley Temple starred in a number of box office hits, including *Stand Up and Cheer* (her first big hit) and *Little Miss Marker*. She was six years old, the same age Warhol was when he sent her a fan letter. She, in turn, sent him her autograph. Thus Warhol got what he (and perhaps his mother as well) wanted, which was acknowledgment from a privileged insider and star.

In 1935 Mickey Rooney (born 1920), who made his stage

debut at fifteen months in an act with his vaudevillian parents and at age seven starred in his own series of motion pictures under the name Mickey McGuire, portrayed Puck in the memorable Max Reinhardt/William Dieterle production of *A Midsummer Night's Dream*. In 1935 Freddie Bartholomew (born 1924) played young David in *David Copperfield*; and in 1936 he starred in *Little Lord Fauntleroy*. In all of these film fairy tales, their lush, grisaille embodiments of the elsewhere, we might see the source of the first stirrings of Warhol's desire to be someone else, someone who is beautiful, and for whom looks, charm, fame, and success were interchangeable.

The world of movies, the realms they imagine and make real, happens in a dark theater. It is a solitary world in which the audience is an anonymous voyeur. As a voyeur, one is always an outsider, and experience is endlessly vicarious. It is this relationship with the world that Warhol echoes when he becomes an artist.

Hollywood is this culture's "dream factory." It is an industry committed to churning out one fantasy after another. It is the believability, as well as the availability, of the elsewhere that must have appealed to a shy, awkward boy who was learning to hate his body and the way he looked. He was a man who stood in photo booths and repeatedly took his picture while changing expressions, holding his hand in front of his face and wearing sunglasses. He was obsessed with his looks, even though they caused him great discomfort. When Colacello finally got inside Warhol's house (he and a few friends were invited for dinner there after Warhol died and before his estate was auctioned off by Sotheby's), he listed twenty-five different

bottles and packages of beauty products crammed in the artist's bathroom cabinet. It was "only about a quarter of what was on those shelves."

For Warhol there were two Americas, the one where he felt uncomfortable and the one he experienced vicariously. In the movie theater he could cover his displacement with flickering images. He could imagine himself as someone else (how he must have hated and loved that feeling), someone bathed in film's amniotic light. He could leave who he was behind and become what he was seeing, which was an image or bodiless surface. And he would, as he knew, eventually be delivered back into the sunlit streets, exhilarated and disappointed. Like the stars he gazed at, movies must have been both intensely attractive and bitterly disappointing for him. They described a meanwhile that would forever elude him. The language Warhol would in his lifetime master, the one his parents never learned to express, is one that tries to disguise its rage and obsequiousness. It is the language of someone who is desperate to belong.

LIII

In 1986 a west coast video company released an X-rated film, *10 and ½ Weeks*, which parodies both the sexual content and narrative premise of *9 and ½ Weeks*. Centered in San Francisco, the pornographic version tells the story of a woman whose sexual appetites and need for revenge are too much for the man who initially forces her to fulfill his sexual fantasies. In one of the lovemaking scenes, the man wears on his forehead a round, moon-like mirror, resembling something a doctor would use, and straddles the woman. He orders her to reach up and touch the mirror and to stroke it while saying her name aloud.

In many religions and cultures, the moon is regarded as a sign of fertility, and thus associated with women. It was once believed that marriages should only be performed when both the sun and moon were visible in the sky. In the Tarot, the *Moon* symbolizes the process of spiritual and biological evolution. In his poem "The Moon Is the Number 18," which is based on the symbols in the Tarot's *Moon*, Charles Olson describes it as "a monstrance" which is the vessel in which the host (or body of Christ) is held and consecrated during mass. Olson recognizes the *Moon* as a vessel that contains portents of the future.

In *10 and ½ Weeks* the actress sees and strokes an image of herself, making the man's face into hers. It is her face she is making love to, but it is his voice and body she is obeying. Thinking of Olson's "monstrance," one could say that the movie defines a woman as the passive receiver or vessel in which a man's desires can express themselves. One implication is that all sex is a form of masturbation, and that other bodies

are merely malleable devices to enhance this private pleasure. Another is that sex is a power struggle between two antagonistic forces, and that one force must gain control over the other's body and become its guiding inner voice.

In another scene from *10 and ½ Weeks*, this one preceding the first time the man and woman have sex, each is shown at home after their first date, masturbating. The woman reaches orgasm but the man doesn't. In order to be fulfilled, the man needs the woman's body but the woman doesn't need the man's. The scene with the man wearing a doctor's mirror is a variation of this perception. Certainly this difference underscores the likelihood that the film is directed toward an audience that subscribes to various cultural attitudes toward women.

In this regard, both *10 and ½ Weeks* and *9 and ½ Weeks* are alike: both play with conventions rather than exposing them. At the same time, both the masturbating and mirror scenes in *10 and ½ Weeks* evoke as well as revise the one in *9 and ½ Weeks* in which Kim Basinger masturbates while looking at slides at the art gallery where she works. The slides' flickering images are like a semi-transparent or tattooed skin playing across her feverish face and disheveled body, and are suggestive of the displacement Basinger's character is undergoing in order to be satisfied sexually. She is at work but, in this particular scene, she can't keep her mind off the male character played by Mickey Rourke. The routine actions of her job remind her of how disturbed her attraction has made her feel. She is a woman possessed. For Basinger's character, masturbation is the only way she can both reinhabit her body as well as temporarily expel the spirit that has possessed it. Sex, the film suggests later,

is the one way a woman can abandon her body as well as embrace the fire inhabiting it. The masturbation scene was, it is said, filmed in the ground-floor space of a building owned by Donald Judd, a sculptor who believes there is no room in art for metaphor or symbolism.

Toward the end of the film, *10 and ½ Weeks* reverses the central premise of *9 and ½ Weeks* by establishing that the woman is the strong character and the male is the prisoner who in the end must break free of the relationship. The X-rated film confines its narrative reversal to its surface, which makes it the mirror of a better-known Hollywood film. It plays with another film's conventions. An X-rated mirror faces an R-rated mirror that was based on a true story.

What happens when a movie revises and edits a tragic autobiographical narrative (a woman's season in hell) and turns it into a popular and titillating entertainment? What happens when that film is mirrored by an X-rated movie that proposes to be about a woman's insatiable sexual desires and the fact that no single man or woman can fulfill them? What happens to the original mirror or narrative that was based on actual events and was written by a woman who, in order to protect her privacy, used a pseudonym? Among other things, someone's pain is turned into a vicarious pleasure. Which of these mirrors gives us insights into what it is to be human and which continues to reflect cultural myths?

The actress or star of *10 and ½ Weeks* is named Barbara Dare, which one assumes is a pseudonym. Among those listed in the film's production crew is someone named "A. Warhola." We might ask if is this a pseudonym as well. We might also ask

what this "A. Warhola," located as it is in an X-rated narrative, shows us about Andy Warhol, and where he and his work have been located in art history. We might remember that Andy Warhol, the artist and filmmaker, claimed there was nothing behind his art and that it was all surface. Given the conjunction of A. Warhola and Andy Warhol, we might begin asking ourselves what their work actually reflects upon.

LIV

ACCORDING TO Jean Stein and George Plimpton, the editors of *Edie: An American Biography* (Alfred A. Knopf, New York, 1982), Andy Warhol was born on October 28, 1930. A reproduction of a birth certificate of an Andrew Warhola, who was born in Forest City, Pennsylvania, was included in their book. Warhol insisted this was a forgery, though he produced no evidence to the contrary. He even told Pat Hackett, his diarist, that Stein and Plimpton were wrong, but he didn't tell her why.

In various interviews Warhol revealed that he was born in 1925. In others, he said that he was born in 1931. At different times he stated that he was born in McKeesport (a working community south of Pittsburgh); Philadelphia; Cleveland; Newport, Rhode Island; and Hawaii. He once claimed, "I come from nowhere." In the David Bailey film portrait, *Andy Warhol, 1971*, he had the actress starring as his mother say that she gave birth to him alone at midnight in the middle of a fire.

In his monograph, *Andy Warhol* (Abbeville, New York, 1983), Carter Ratcliff lists Warhol's birthday as September 28, 1928, and his birthplace as "Forest City, Pennsylvania (a small town northeast of Scranton)." According to Ratcliff, Warhol had one older brother (John) and one younger brother (Paul). His parents were Ondrej (Andrew) and Julia Zavacky Warhol.

In the most reliable chronology, which was compiled for Warhol's MOMA catalog, Marjorie Frankel Nathanson acknowledges the estate of Andy Warhol and the Andy Warhol Foundation for the Visual Arts for giving her access to "the papers in their collections" and states that Warhol was born

Andrew Warhola on August 6, 1928 in Pittsburgh to Andrej (born 1886) and Julia (née Zavacky) Warhola (born 1892). He had two older brothers, Paul (born 1922) and John (born 1925).

The birth certificate Stein and Plimpton reproduced in their book was real. It had been issued to another person, christened Andrew Warhola by his parents. Had Warhol truly believed that we would all one day be alike, he would have seen the humor in this coincidence. He would have celebrated the fact that a little more than two years after he was placed on this earth, someone with his name and thus an identical twin in at least one respect was sent to keep him company.